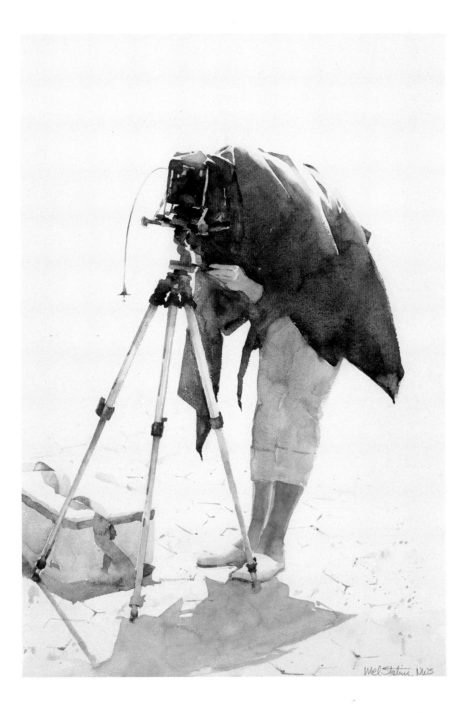

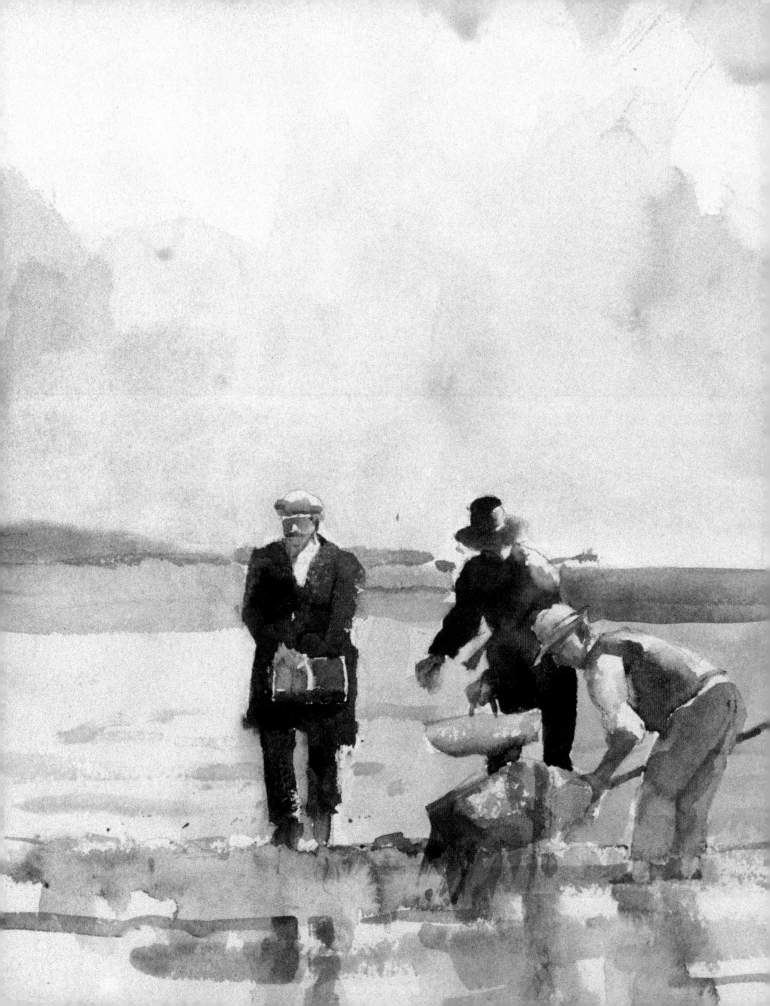

The FIGURE in WATERCOLOR

Simple, Fast, and Focused

MEL STABIN

WATSON-GUPTILL PUBLICATIONS

Acknowledgments

Thank you to all my students, who have shared my passion for painting. I am also grateful to Candace Raney, my senior acquisitions editor, who enthusiastically encouraged me to write this book, and to Jacqueline Ching, my editor, who helped make sense of what I wanted to say.

A very special thanks to my daughter, Nesa Susan, for all of her hard work in preparing my manuscript, and for her welcome opinions.

COVER ART: *Elegance*, 22 x 15" (55 x 37.5 cm).
 Collection of Fred and June Kummer
PAGE 1: *Picture Taker*, 22 x 15" (55 x 37.5 cm).
 Collection of Janice Rattray

Copyright © 2002 Mel Stabin.

First published in 2002 in the United States by Watson-Guptill Publications, a division of VNU Business Media, Inc., 770 Broadway, New York, NY 10003
www.watsonguptill.com

SENIOR EDITOR: Candace Raney

EDITOR: Jacqueline Ching

DESIGNER: Patricia Fabricant

PRODUCTION MANAGER: Ellen Greene

Library of Congress Cataloging-in-Publication Data
Stabin, Mel.
 Painting the figure in watercolor : simple, fast, and focused / by Mel Stabin.
 p. cm.
Includes index. ISBN 0-8230-1694-3
 1. Human figure in art. 2. Watercolor painting--Technique. I. Title.
 ND2190 .S73 2003
 751.42'242—dc21 2002012690
Printed in China
First printing, 2002
1 2 3 4 5 6 7 8 9 / 10 09 08 07 06 05 04 03 02

The cover of this book is a tribute to my father, who was a milliner. I've always been attracted to painting women wearing large-brimmed hats.

This book was written in honor of my parents, who instilled in me the value of working hard and encouraged me to become an artist long before I realized I could.

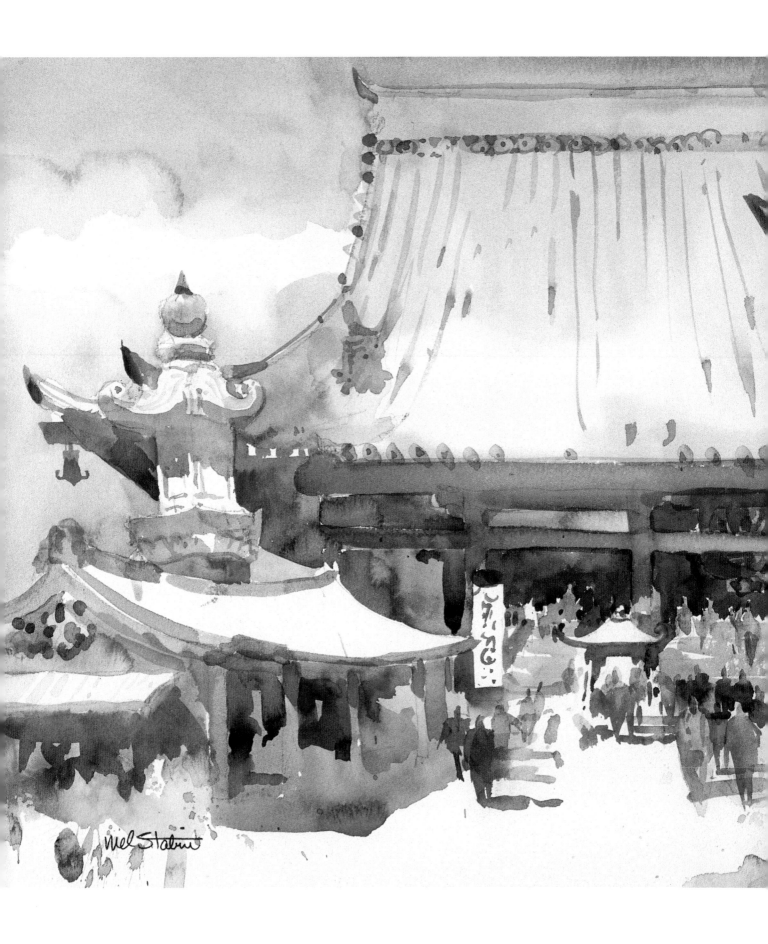

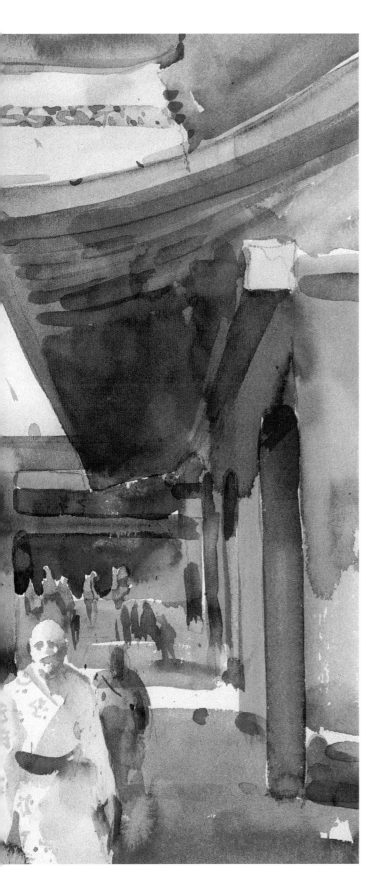

Contents

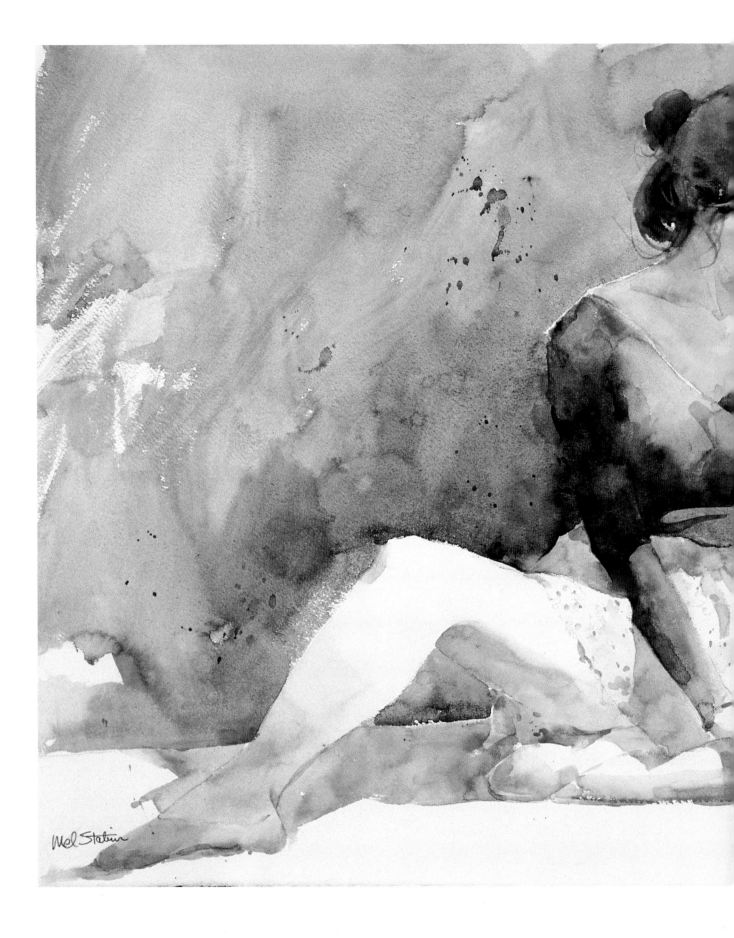

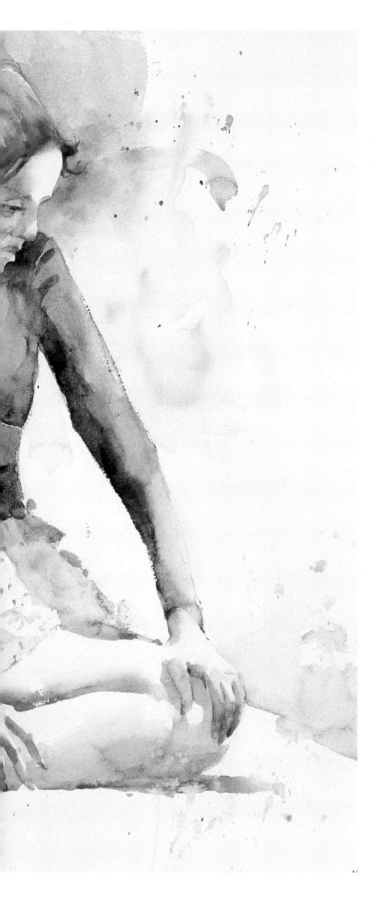

Preface

I have enjoyed a love affair with watercolor for a long time. Its unpredictability continues to excite me. This relationship began the first time I painted a model in Edgar Whitney's class at the Pratt Institute. I was awed by Ed's description of how light falls on the figure. That was a wonderful, inspirational moment in my life. For the next six years, I devoted my energies to painting landscapes with Ed in his on location workshops. But I continued to sketch the figure whenever I could.

Since then, I have actively focused on painting people. The desire to do so has always been there, but it has now become my passion.

There is a Chinese word, *Wu-hsin*, which literally means "no mind." It suggests a state of being in which the mind is allowed to react and perceive without conscious control. It is the ideal state of being. If we could only get into this state of being, some very good work might arise from it. Our impressions are unique and very fragile and can easily be lost if we are not careful to protect them.

I hope to convey some of my personal insights, help guide you in your own exploration, and convince you that if you have an insatiable appetite for knowledge, if your work is sincere and you are productive, you will be successful in the best sense of the word.

Dancer, 22" x 30" (55 x 75 cm)

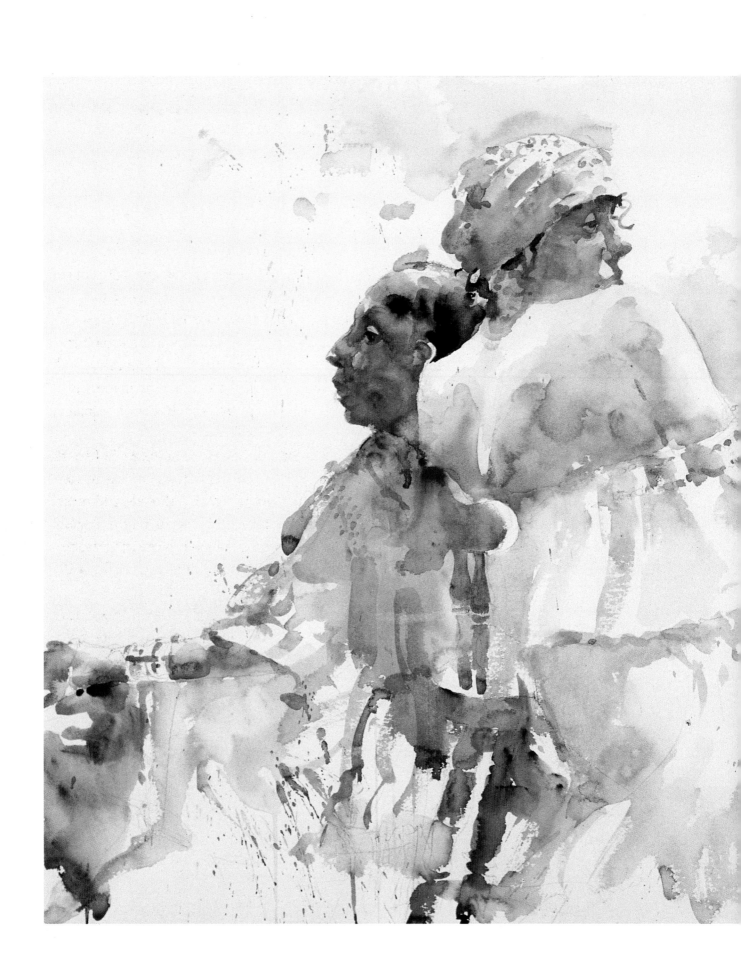

Introduction

*E*verybody is fair game for my brush. I delight in painting all kinds of people. The human figure is the most sensual of subjects. Unlike inanimate objects, people are different. They have unique personalities, shapes, color, expressions, and attitudes. These multifaceted qualities give us more to relate to and contend with. But don't despair. Help is on the way.

The attitude, mood, or gesture of a person is often fleeting. To capture the moment, you must paint simply, quickly, directly, and most importantly with intense focus on the *essence* of the person. The artist must be sensitive to a subject's inner qualities as well as physical appearance.

In this book, you will discover design aesthetics, composition, shape, value, color, light and shadow, and technique. But these are only a means to an end. The painter should never lose sight of his goal to focus on the essence of his subject.

Now let's begin our journey through this book together.

Laverne and Bobbie
22 x 30" (55 x 75 cm)

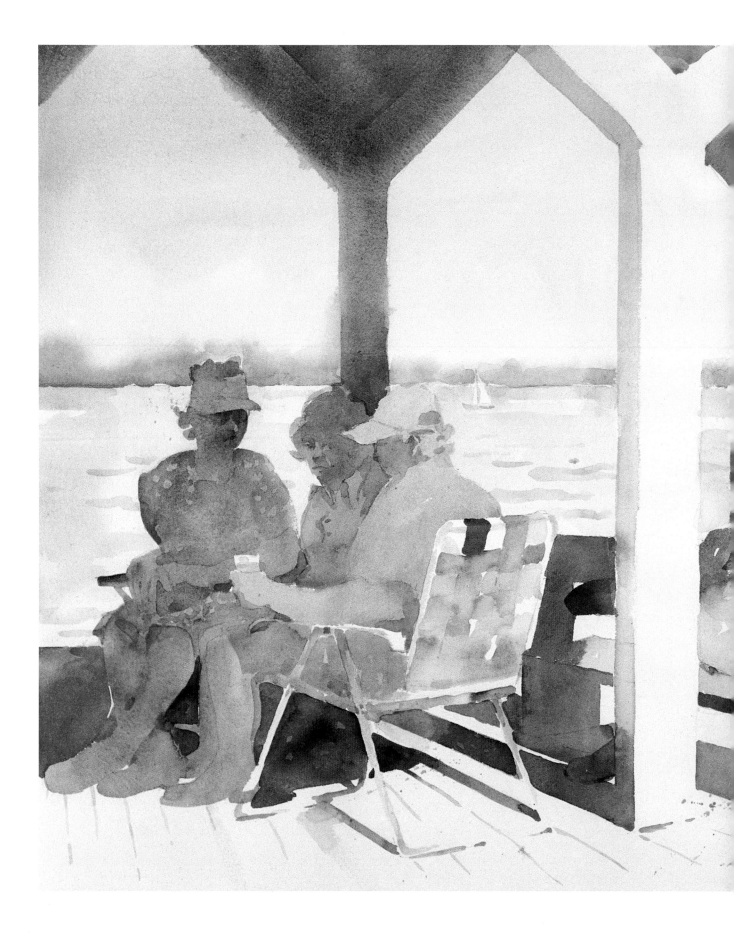

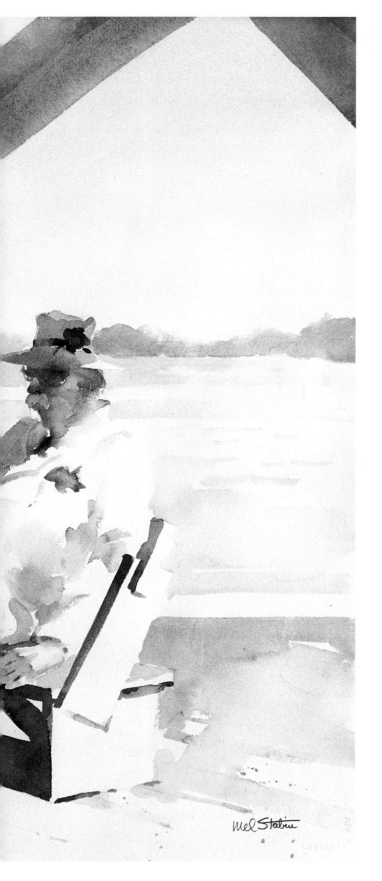

Materials and Equipment

We painters are a curious lot and are often tempted to buy all of the gadgets that are available for purchase. Early in my painting career, curiosity often got the better of me. I must have experienced most of the gadgets on the market. I guess it's part of the process.

But over the years I have managed to cut back on my materials and painting equipment. Now my criterion is to keep it simple. Whatever tool is most efficient for the job at hand is best.

Shady Ladies and a Gentleman
15 x 22" (37.5 x 55 cm)

Studio Equipment

My drawing table is large enough to hold a full sheet of paper. It is adjustable, and I keep it tilted at about a 15-degree angle. An adjustable lamp with full spectrum illumination is clamped to the side of the table for working at night (which I rarely do). Next to my drawing table is a lightweight steel tabouret with three open shelves. Casters make it easy to move when necessary. The table is located next to a large window, because it is always preferable to paint in natural light.

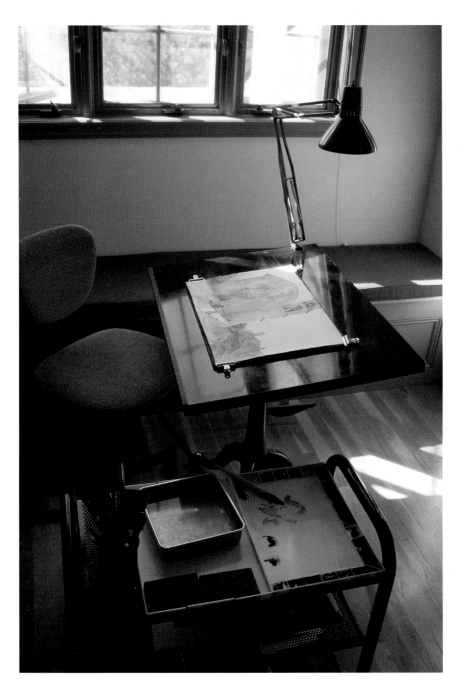

Keep the working area as simple and uncluttered as possible. My studio is quite spacious (20 x 30') and contains a ten-drawer flat file for storing paintings, paper, and mat boards; a large table for cutting mats and framing; a storage closet; and a sink for water.

Outdoor Equipment

Ah!...the search for perfect outdoor equipment—it never seems to end, does it? Since I travel so much conducting workshops, my equipment specifications are important. Everything has to fit into one carrying bag or backpack (see below). The carrying bag has to be light and strong and fit into the overhead compartment of a plane. I never check in my equipment at the airport. It stays with me. If the airline loses it —and as you know, this can happen—I'm out of business!

For an easel, I use a sturdy but very light camera tripod with retractable legs (see next page). A tilting adapter, which screws onto the tripod, holds the board that the paper is clipped to. A strong plastic tray for my John Pike palette is clamped to the legs. I also put an 8"-square aluminum baking pan on the tray for water. A brush holder with an assortment of brushes clamps onto the leg of the tripod.

These and a variety of other attachments are available from Sun-Eden Artists' Gear, which manufactures artists' equipment.

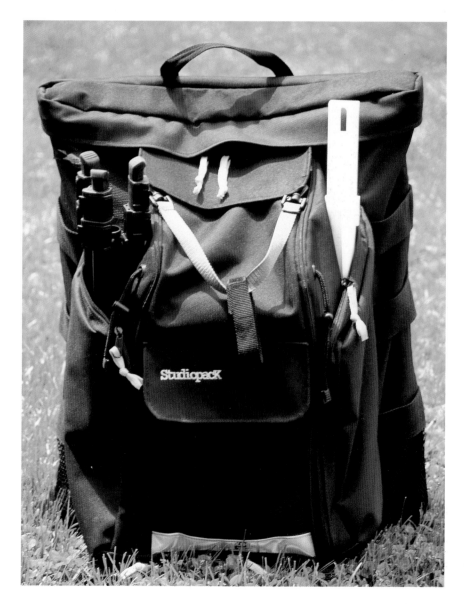

Everything that you need to paint outdoors can be packed into this sturdy backpack. It is made of polyester and nylon waterproof-coated fabric. There are a variety of compartments that will hold half sheets of watercolor paper, palette, brushes, tripod or easel, tray, umbrella, and miscellaneous items.

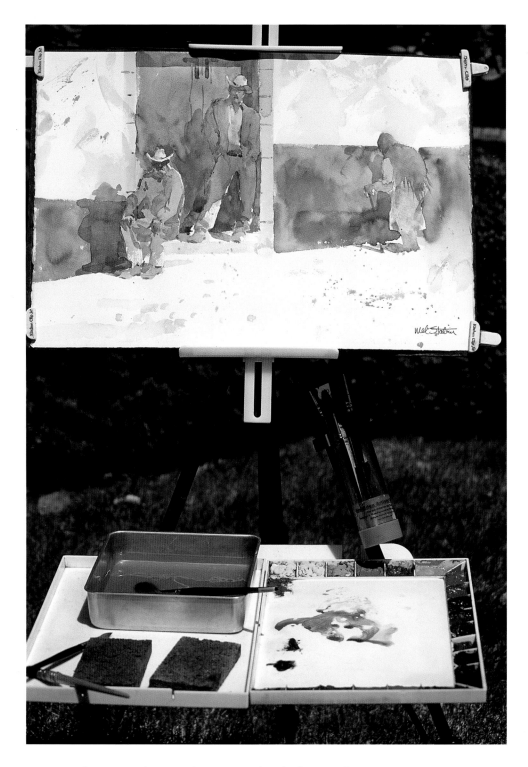

By attaching a tilting adapter and a lightweight tray, a camera tripod easily turns into a portable artists' easel. Also shown is a brush holder clipped onto one of the tripod legs.

Drawing Tools

Ideal for drawing is a 2B or 4B graphite pencil, which is dark enough, while being kind to the paper. Avoid using an H pencil. It is too hard and can dig into your paper like a nail.

Nevertheless, it's good to experiment with different drawing implements. Anything that makes a mark can be used: a brush, charcoal, goose quill and ink, calligraphy pen, felt-tip pen, twig. Get to know the possibilities.

Palette

I use the John Pike palette for studio and location work. It contains twenty generously sized wells and a large mixing area. It measures 10 x 15" and is made of durable injected plastic.

There are other palettes available but some are of inferior quality and can crack easily, so be forewarned. The colors are arranged clockwise from light to dark and warm to cool within color families (see below).

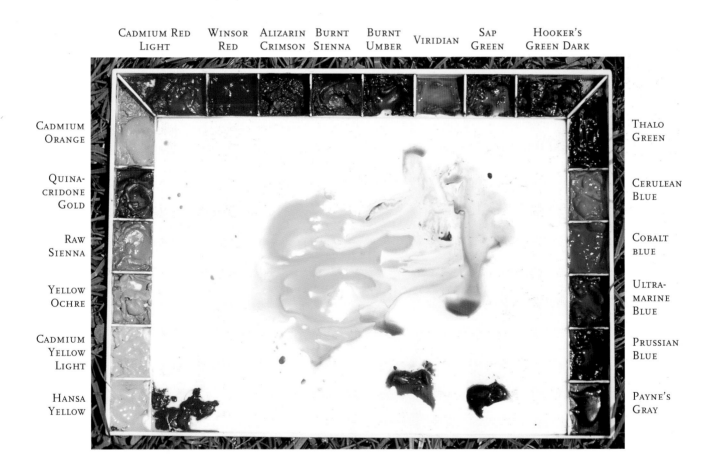

CADMIUM RED LIGHT · WINSOR RED · ALIZARIN CRIMSON · BURNT SIENNA · BURNT UMBER · VIRIDIAN · SAP GREEN · HOOKER'S GREEN DARK

CADMIUM ORANGE · QUINACRIDONE GOLD · RAW SIENNA · YELLOW OCHRE · CADMIUM YELLOW LIGHT · HANSA YELLOW

THALO GREEN · CERULEAN BLUE · COBALT BLUE · ULTRAMARINE BLUE · PRUSSIAN BLUE · PAYNE'S GRAY

I prefer the John Pike palette. It is sturdy, lightweight, and because it is only 5/8" in thickness, it easily packs flat in your carrying bag or luggage.

Brushes

Every brush has a specific function and makes its own distinctive mark. Brushes vary in size, feel, quality, and cost. I have about a dozen brushes in my kit but usually employ just two or three per painting.

The Raphael "mop" brush holds a lot of water and paint and is useful for painting large shapes. In my opinion, round brushes are preferable for painting people. They are more sympathetic to describing the round contours of the human figure. I have an assortment of round brushes—#14, #12, #10, and a #6. The brush that I find most valuable for painting the figure is my #12 Kolinsky.

A long-hair rigger brush is valuable for its "spunkiness" and makes active, calligraphic marks.

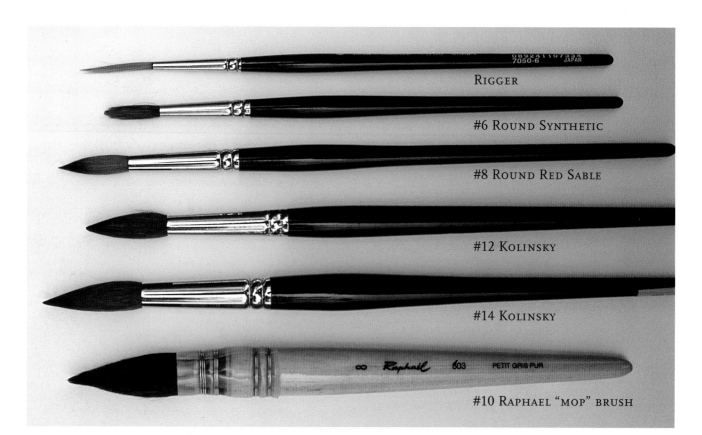

RIGGER

#6 ROUND SYNTHETIC

#8 ROUND RED SABLE

#12 KOLINSKY

#14 KOLINSKY

#10 RAPHAEL "MOP" BRUSH

These are the brushes that I use for my figure paintings. The #14 and #12 Kolinsky brushes are used more than any other. They are considerably more expensive than sable and synthetic hair brushes but they're worth it.

A good Kolinsky hair brush manipulates the paint beautifully and holds a generous amount of water and paint. The hairs of the brush maintain a sharp point when new, but like all brushes, the point dulls with frequent use.

Paint

Moist, "juicy" paint is mandatory in watercolor painting, so use tube paints only. Dry pan paints will never provide the same color fidelity as tube paints. Use professional or artist grade only please, not student grade. The quality and costs will vary with each manufacturer. I find that Winsor & Newton, DaVinci, and Holbein make "creamy" colors of a high standard.

Paper

I use a variety of papers for different purposes. They are all of high quality, 100 percent rag content. I usually work with 140 lb.-weight papers, though occasionally, I will work on 300-lb. paper. My choices are Arches, Fabriano, and Lanaquarelle cold-pressed paper. When the need for "dry brush" arises, I will use Arches rough. Lanaquarelle offers a bright white surface.

Some papers, such as Strathmore Aquarius II, are a composite of natural and synthetic fibers, and work very well. The surface of this paper is between a cold-pressed and hot-pressed texture, and you can apply velvety, smooth washes to it.

Strathmore bristol board can take a beating and allows you to "lift" paint easily. These are all personal choices, and I would suggest that you explore the many surfaces and weights available.

Miscellaneous

• A CONTAINER FOR WATER. My preference is an 8" square, 2" high aluminum baking pan. It is light and packs easily for on-location work. You do not have to dip your brush beyond the ferrule to reach the bottom of the pan, thereby saving wear and tear on the brush handle where it meets the ferrule. It is also easier to tamp paint out of the brush in a shallow pan.

• A PACKET OF TISSUES for softening edges.

• A soft rag for removing water from a brush.

• A COUPLE OF SYNTHETIC SPONGES to check excess water from the brush while painting. When the damp sponges are left in the closed palette, they provide moisture for your paints.

• A RUBBER SPATULA for "lifting" paint from the paper.

• A KNEADED ERASER to correct your drawing. It will not mar your paper and lasts a long time.

Drawing the Figure

"I shut my eyes in order to see."
—PAUL GAUGUIN

*D*rawing is an important first step in the painting process. Your drawing not only reflects the first impression that you have of the figure, but also reflects your personality.

An accurate rendering may not be as expressive as a loose drawing. A well-done caricature expresses the essence of a person with very few lines. Just look at the work of Al Hirschfeld, the *New York Times* caricaturist, and you will see what I mean.

To capture the essence of a person, you must be able to draw expressively. To draw expressively, you must draw often. I always recommend that budding artists attend drawing classes before delving into painting. I continue to go to open sketch class as often as possible to hone my skills,...and because I love to draw people. This chapter is devoted to *seeing* the figure, composing the drawing, and loose gesture and contour drawing.

Touching Toes

21

Seeing the Figure

To draw expressively, you have to empathize with your subject, try to feel what he feels. Before you begin, allow yourself a few moments to get a sense of the figure. Develop that impression.

Seeing is another word for empathizing. See with your mind and heart, as well as your eyes. To see the figure well requires knowledge and experience. A useful exercise is to take one to five minutes to sketch several quick poses. Try to capture the spirit of the figure.

Every figure is different. Some models are in touch with their bodies and move fluidly. Some are stiff or awkward. All of them can provide you with an opportunity to do great work, as long as you can *see* and draw them honestly and expressively. It is better to create a drawing that lacks accuracy, as long as it has energy and is direct. If your drawing is timid, it will convey your insecurity.

Remember that when drawing the figure, you are like an actor playing a role. It requires that you "lose yourself." When this occurs, good things happen.

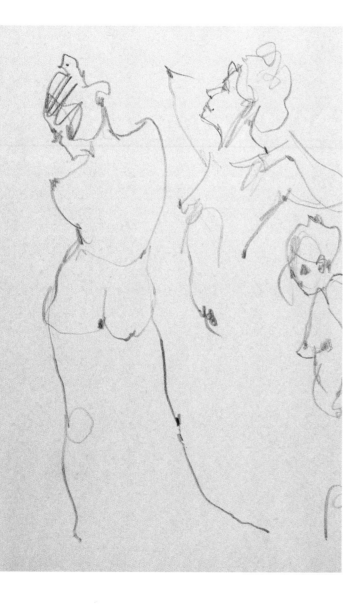

In this one-minute sketch, as in the ones that follow, I was only interested in the essence of the pose. Note that the figure is incomplete and that the gesture of the pose is expressed with very few lines. Don't be hesitant in your line work. Draw with conviction.

Composing the Drawing

The area that the figure occupies on the paper is very important. Just as in landscapes or still lifes, it is necessary to distinguish spatial relationships. You must be concerned with relationships of positive and negative shapes and the dynamics that they create. The drawing need not always be of the full figure. Drawing part of the torso, filling up the paper with the image, placing it in an interesting area of the rectangle often results in an exciting composition.

Charcoal drawing on newsprint paper. This five-minute study allowed me enough time to block in some shadow values indicating where the light fell on the figure.

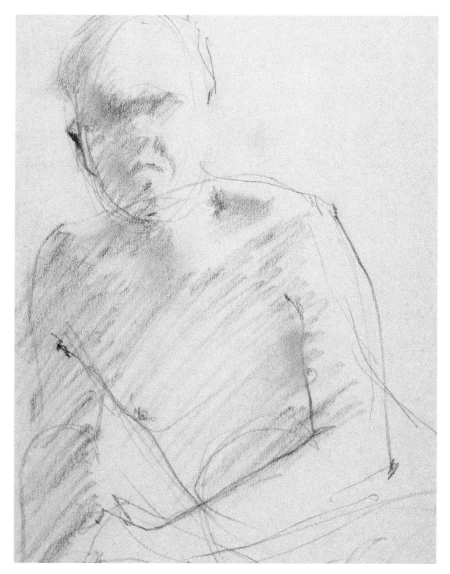

Loose Gesture and Contour Drawing

Long, casual, rhythmic lines should be used to reflect the gesture, or pose, of the model. These rhythms show how you first visualize the pose. Don't be concerned if the drawing is accurate or not. What matters is that it is expressive. You can always build on your first impression or correct a drawing with additional lines as you get a sense of the figure.

Let yourself go. Chances are your work is not going to appear in the Louvre, so why worry?

Use your elbow or shoulder as a fulcrum to get some big rhythms in your drawing. Get "loose." Have a nonchalant attitude in your drawings. As Degas said, "Only when a painter no longer knows what he is doing does the painter do good things."

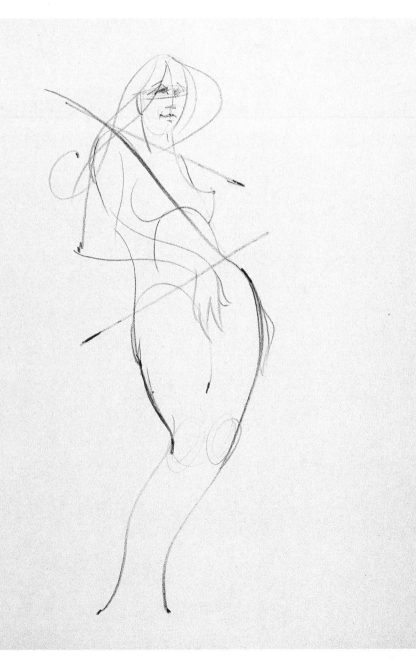

Look for the long rhythms of the pose. This drawing was a demonstration to emphasize the flow of the body. The long line from the shoulder through to the hip and down the length of the leg captures the essence of the pose. Note the exaggerated axis of the shoulders and hips.

"You will never draw the sense of a thing unless you are feeling it at the time you work."

—ROBERT HENRI

This page of one-minute poses is made up of quick gestural lines. The technique of rapidly sketching the model obliges you to focus on the gesture of the pose and nothing else. Some of the figures overlap, which results in interesting patterns.

BELOW

I emphasized the angles, twists, and turns of the body. When I came to a change in an angle of the figure, I leaned on the pencil and followed the contour in the new direction. For longer, curved lines I let the pencil fly, as in the second figure. This drawing combines both gestural and contour line work.

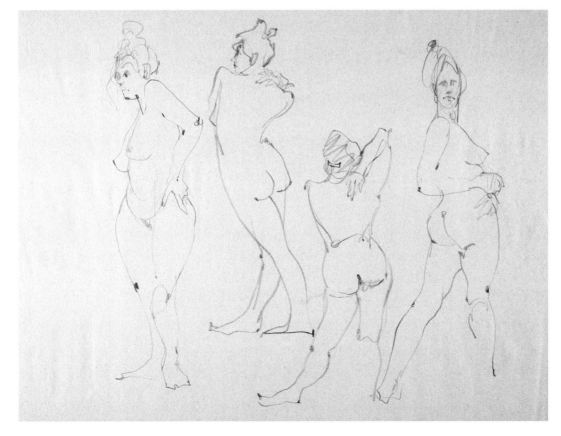

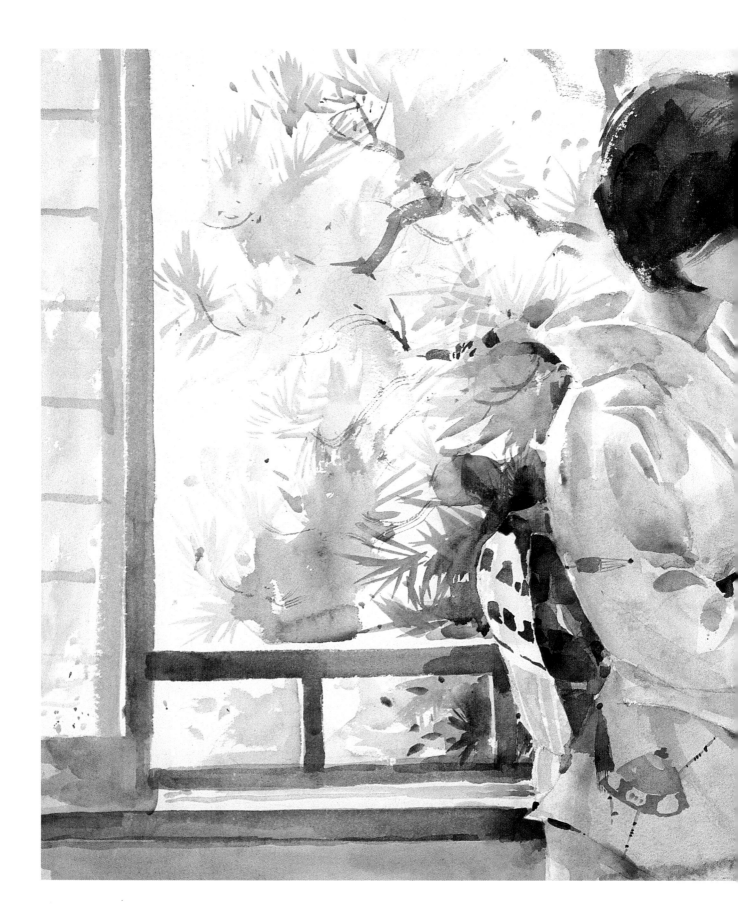

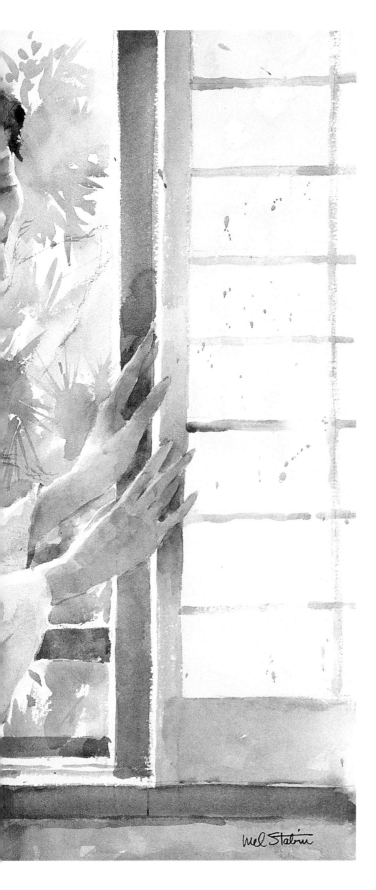

Painting the Figure

What you choose to omit in a painting is as important as what you choose to depict.

One of the difficult problems that the less experienced artist encounters in painting the figure is identifying and simplifying what he sees. More often than not, he sees too much and tries to include everything.

Understanding that a painting is a translation of what you see and not a literal rendition of the subject is of primary importance. You will be on your way to better painting when you begin to see the figure through its value and color, as it is described by light and shadow. Values are the range of tones from white to black on any object (see Figure A). You should devote your energy to the relationship of these elements, not to copying reality.

Yoko, 22 x 30", (8.8 x 12 cm)

Painting Directly

Using the brush and pigment directly to paint the figure without prior drawing is a very spontaneous and exciting way to work. It is a great confidence builder. Block in large shapes of color and value. You can create exciting compositions this way, because you are free from the impulse to fill in the lines of a drawing. Instead, your overriding concern is for shape and spatial relationships.

Matisse, Dufy, Picasso, Marin, and Dong Kingman are just a few of the great artists who painted directly with the brush. You can paint directly on a dry surface or on a wet surface. On a wet surface (known as the wet-in-wet method), you have to use more pigment in the washes because the moist paper will dilute the color considerably. The color will dry 20 to 30 percent lighter than if applied to dry paper.

In this method, the brush drawing becomes the most important element of the painting. Either the drawing (line work) or the washes (shapes) should dominate. They should not have equal prominence. This is not a hard fast rule—little in art is—but it is a valid theory.

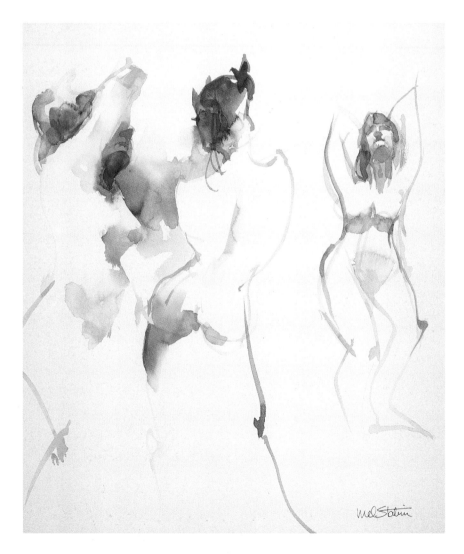

One Figure, Three Times
14 x 12" (35 x 30 cm)

Drawing with the brush is a very fluid method of working. This is evident in traditional Japanese art. A level of confidence is required because the brush marks are permanent. The drawing can be done with one color or any combination of colors, any thickness of line, and any number of different tools.

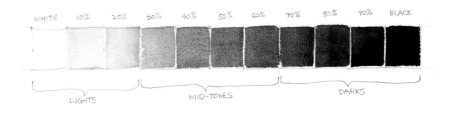

VALUE CHART

| WHITE | 10% | 20% | 30% | 40% | 50% | 60% | 70% | 80% | 90% | BLACK |

LIGHTS — MID-TONES — DARKS

Figure A
White to Black Value Chart

A painting that ranges in value from white to about a 30 percent tone is referred to as "high-key." A "low-key" painting ranges in value from 60 percent to black.

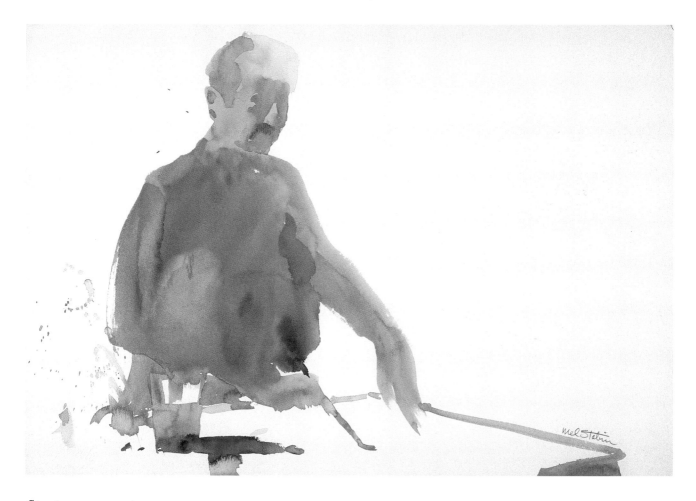

Staats, 11 x 15" (27.5 x 37.5 cm)

I did this eight-minute direct painting of Staats, an art teacher and painter, by going for the silhouette. Essentially, I used two washes to describe form. The first wash was for the value and color of the hair, face, and shirt. The second wash simply described the shadow of the face and shirt. The washes were applied as simple, flat shapes.

The Big Shapes First

The best paintings consist of very few shapes. Think from the whole to the parts, big shapes to the little shapes, mass to detail. Focus on establishing relationships of value and color at the very beginning of the painting.

Shapes that are composed of contrasting values of light and shadow—as seen in the face in *Queen Mother of Ghana* (see p. 33)—demand greater attention than shapes that are close in value. You can see shapes that are similar in value by squinting hard. If you blend them together, you will create fewer shapes and your painting will be more cohesive and dynamic.

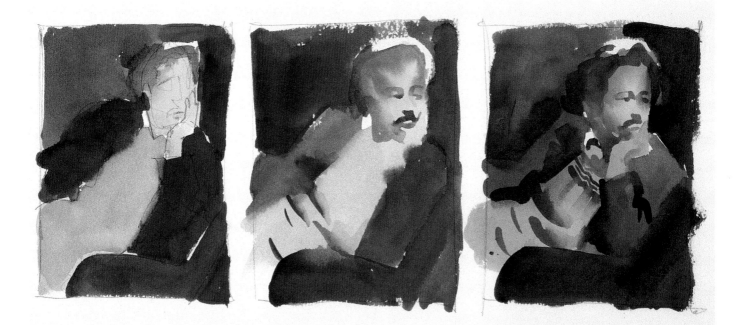

I blocked in the large shapes of value and color in this initial stage. The value pattern is comprised of a light midtone and dark value. No detail at this stage, just flat washes.

A second wash begins to describe the form of the face and some folds in the sweater. I slowly begin to build on to the large shapes.

In this final phase, I suggest the design on the sweater and further form description of the hair, face, and hand. Folds in the sweater and jacket are indicated. Concern for detail occurs only in this latter stage of the painting...not in the beginning.

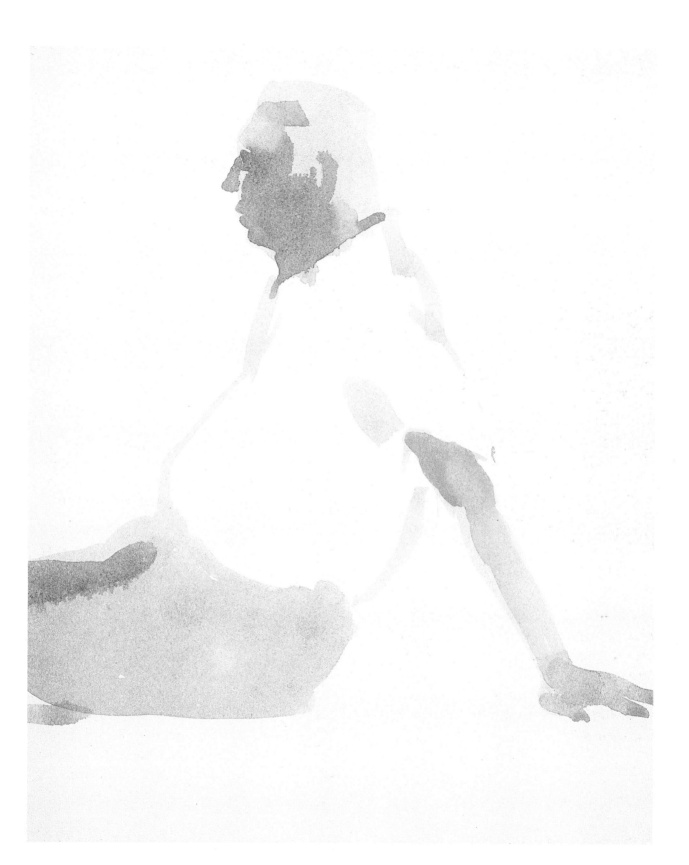

Profile, 10 x 8" (25 x 20 cm)

An exercise in simplicity. Here I used flat washes with a limited palatte.

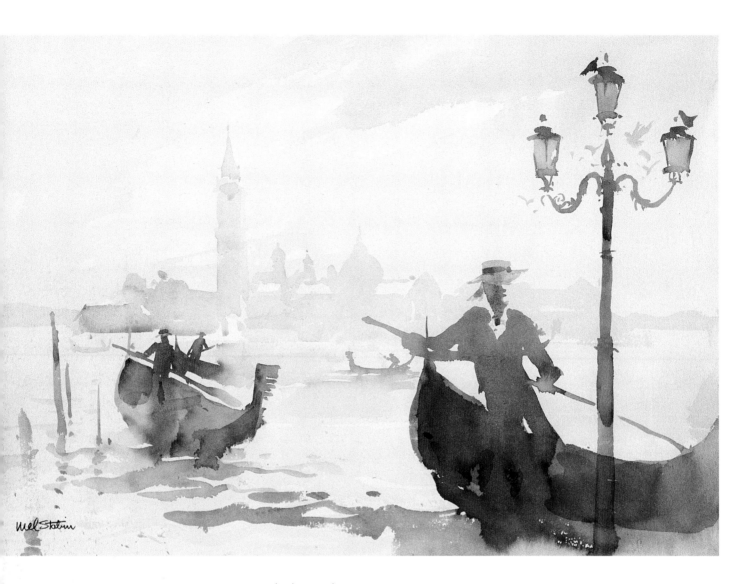

Rain in Venice, 15 x 22" (37.5 x 55 cm)

I was anxious to paint the activity of the gondoliers racing to shore during a rainstorm. First, I divided the paper into two major horizontal shapes—the distant shore and the body of water. The meandering rhythm of the gondolas created a visual path to the building on the distant shore. Such spatial relationships are what make a painting dynamic and should be considered before painting begins.

I worked with a limited palette to reflect the mood of the gray day. The paper remained quite damp and you can see some unintentional drip marks of the two forward gondolas, which I think actually added to the painting. Ah!. . .the joys of painting "en plein air." The painting was finished in thirty minutes.

Queen Mother of Ghana, 22 x 30" (55 x 75 cm)

I met this beautiful woman at a Quaker retreat and I could not resist asking her if she would pose for a class demonstration. To my delight and surprise, she agreed. I was later informed that she was the Queen Mother of Ghana, on a North American lecture tour discussing human rights in Ghana.

I sketched her lightly with my brush and then quickly and directly indicated the major shadow shapes on her face, and beautiful textures and rich colors of her royal dress. The glitter of the design on her blouse was indicated with calligraphic marks made with my #14 round brush. I was honored by her graciousness. It was an exciting and memorable moment.

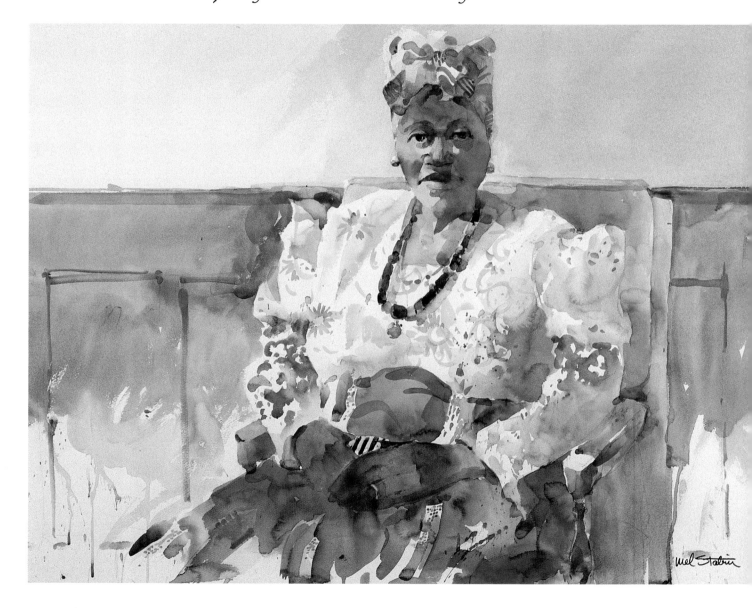

Painting Quickly and Simply

One can argue the merits of different ways of painting: simply and quickly, detailed and slowly, transparently or opaquely, loosely or tightly, etc. Your style of painting largely depends on your personality.

My personality dictates that I paint quickly and loosely. I discipline myself to think and see simply and to be very focused on what I'm trying to say in my painting. The benefit of working simply and quickly is achieving a spontaneous result.

I usually paint *alla prima,* indicating the color and value in the painting with the first wash. There is nothing cleaner, more spontaneous, and transparent in watercolor painting than first washes. If necessary, you can revisit an area with subsequent washes. This glazing method—building up of washes to describe form—is fine, but it should not be overdone, especially if you are using earth colors, which tend to turn opaque after a couple of glazes.

We all want to enjoy the painting experience and of all the mediums to work with. Watercolor is always ready to throw a party. Watercolor is fast, sometimes unpredictable, frustrating, uncontrollable, exciting, and produces beautiful things... if we just let it.

"We fritter away our lives with detail...simplify, simplify."

—HENRY DAVID THOREAU

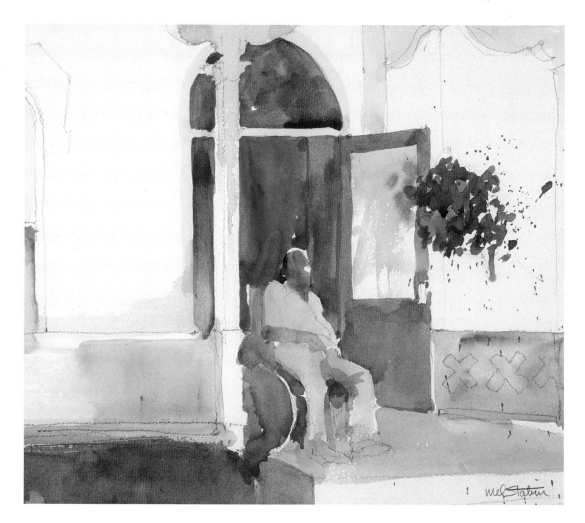

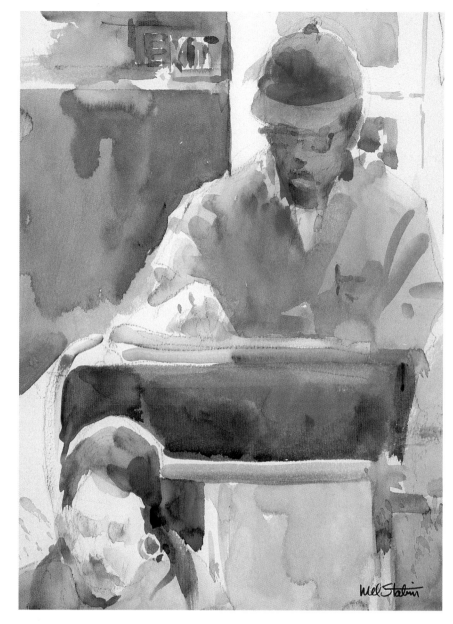

OPPOSITE: Goshen Victorian

15 x 22" (37.5 x 55 cm)

This is only the beginning of a painting, but it illustrates the results you can get by working quickly and staying focused on the overall abstract shapes of the subject. First, I attended to the light value of the figure in the wheelchair, and then the large midtone of the doorway. Some day I will finish the painting. The challenge will be to maintain the simplicity that I started with.

ABOVE: Sketch Class, 22 x 15" (55 x 37.5 cm)

Here I attempted to capture the impression created by the fluorescent overhead light on these two artists in sketch class. I achieved this by imposing a dominance of blue in the painting, and a strong top light, as indicated in the face at the bottom. Again, painting quickly, I blocked in the large shapes of value and color as accurately as I could with as few brushstrokes as possible.

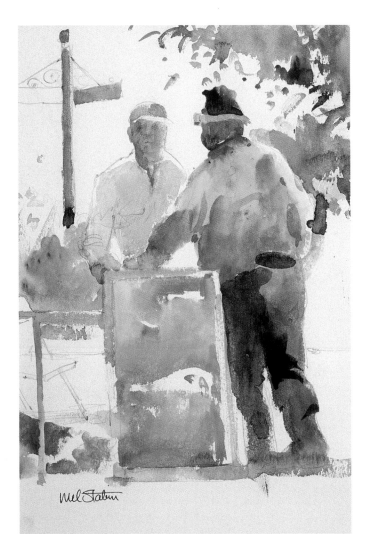

Woodstock Vendor
14 x 11" (35 x 27.5 cm)

Another unfinished symphony. I was anxious to record the activity of this portly gentleman selling his wares on the green in Woodstock, New York. In this early phase of the painting, I devoted my attention to the relationships of color and value in the big shapes, and not to detail. Some shapes blend into one another as in the fusion of the leg into the cast shadow.

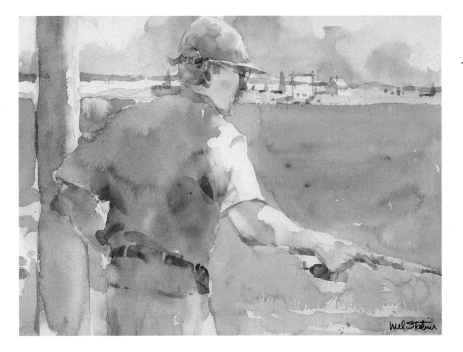

Fishing on the Chappy
15 x 22" (37.5 x 55 cm)

This one-hour demonstration was done on location in a workshop I conducted in Martha's Vineyard. The unifying colors used were Cobalt Blue and Alizarin Crimson. Cadmium Red, Raw Sienna, and Sap Green were used as well. I simplified the large shadow shape of the fisherman's shirt and pants and indicated very little detail in these areas. The lit area of the shoulder and forearm were kept paper white. The white also appears in the distant water and the light side of the house, creating a connection to the figure.

Sculpting the Figure

All form is three-dimensional. We see and describe form through light and shadow. Look at the volume of the figure and the way the various planes are affected by the light. Have a sense of how the muscles and bones relate to form a shape. "Chisel" the body with your brush. Observe how the large shapes relate to one another. If you get them right, the small shapes will fall into place. An understanding of anatomy is required, which can be attained through books, museums, sketch classes, etc. But that's homework.

"I removed everything that was not David."

—MICHELANGELO

(when asked how he created the statue of David)

Shadow Shapes

15 x 11" (37.5 x 27.5 cm)

These one-minute sketches illustrate how quickly a figure can be realized if you follow the shadow shapes accurately. I used one color and value to describe the shadow shape of the figure. The shadow shape determined the light shapes.

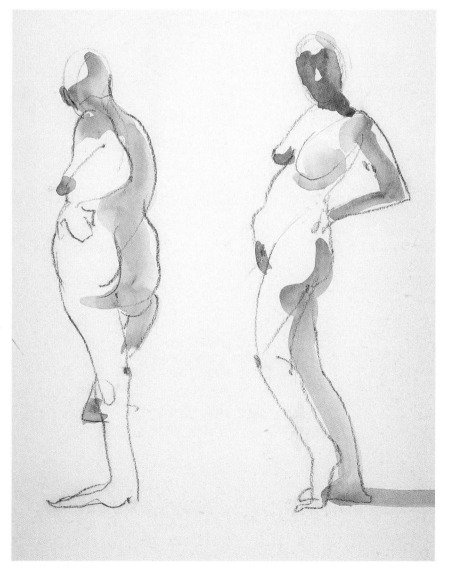

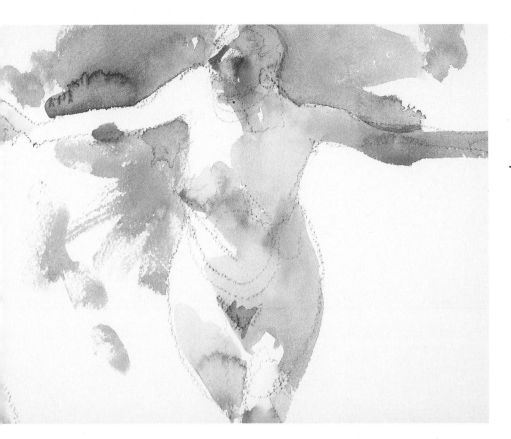

Flying, 11 x 15" (27.5 x 37.5 cm)

One continuous wash of the shadow shape described the silhouette of the figure and described the shapes of the light area. The darker background wash was a foil to bring out the light side of the figure. Note the color changes in the shadow area. The painting time was five minutes.

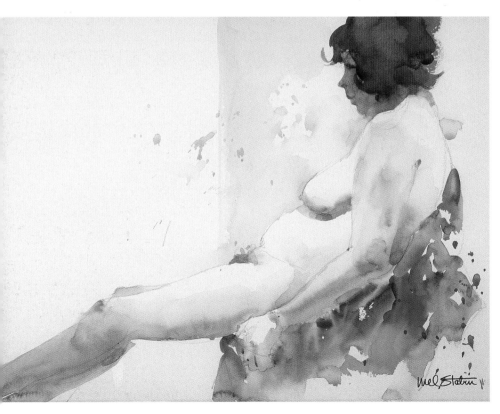

Long Lady, 15 x 22" (37.5 x 55 cm)

A play of positive and negative shapes forms this painting. The legs and head are dark values seen against lighter values. The light on the torso is etched by the subtle value of the vertical shape behind it. The shadow of the arm and lower back is blended into the garment so that the area of interest remains focused on the head and body.

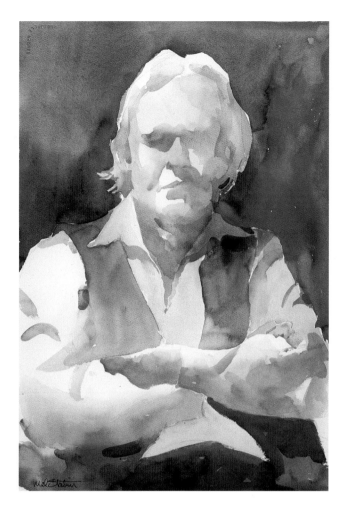

Harvey, 22 x 15" (55 x 37.5 cm)

In this painting, my intention was to describe form with minimum detail. If you get the big shapes right, you can capture a likeness without delineating the features.

Respecting the source of light, I "chiseled" the contours of the skull with simple washes, softening edges in some areas and maintaining firm edges in other areas. I emphasized Harvey's pronounced forehead and deep-set eye sockets.

Drowsy, 15 x 22" (37.5 x 55 cm)

Subtle, high-key values of color were applied in sculpting this figure. The shadow shapes are defined. I was selective in describing the area that interested me, the torso. Though subtle, the strongest color and value contrast occurs there. The face and upper body is secondary in importance.

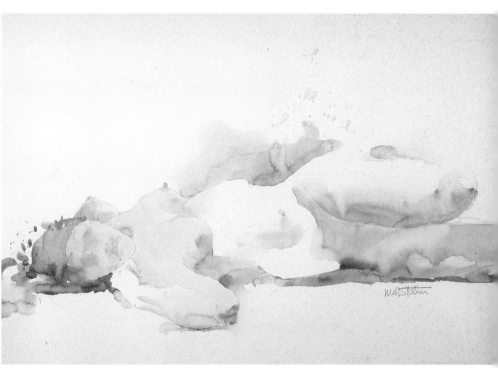

Skin Color

Variations of skin color are endless. It depends on the complexion of the individual and the interpretation of the artist. Skin color ranges from light to dark, red to brown, yellow to olive. The light on the figure, whether incandescent or natural, direct or reflected, will also influence the color of the skin. The specific mood that you create for the painting can also affect skin color. Here are some colors that I use:

Dark Complexion
Cadmium Red, Hooker's Green Dark, Ivory Black, Raw Umber.

Light Complexion
Cadmium Red Light, Cerulean Blue, Yellow Ochre, Raw Sienna.

Yellow Complexion
Sap Green, Cadmium Red Light, Yellow Ochre, Cadmium Orange.

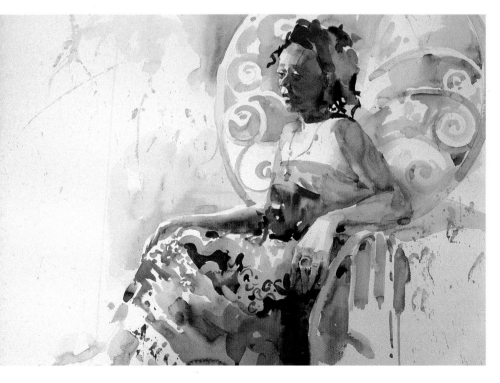

Royal Throne, 15 x 22" (37.5 x 55 cm)

Here, Winsor Red, Raw Umber, Raw Sienna, Ivory Black, and Sap Green were used for the skin. The value of the shadow colors in the face was a dark midtone to reflect the richness of the model's dark complexion.

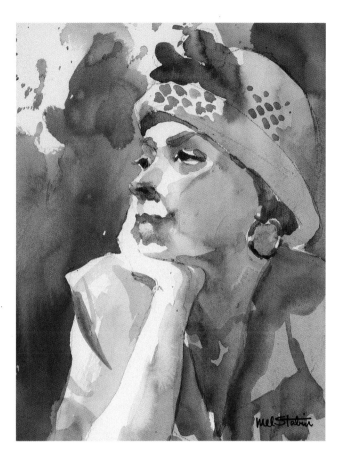

Straw Hat, 15 x 11" (37.5 x 27.5 cm)

The model's skin color was very fair so I kept the washes light and transparent. Colors used were Cadmium Red Light, Cobalt Blue, Alizarin Crimson, Yellow Ochre, and Opera Pink (Holbein).

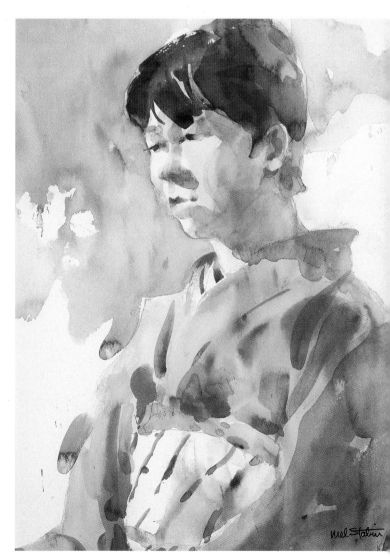

Kimono, 30 x 22" (75 x 55 cm)

For the skin color of this lovely Japanese woman, I used mostly Raw Sienna, Cadmium Orange in the shadow of the face to suggest a reflected light from the orange kimono, Cadmium Red, and Sap Green.

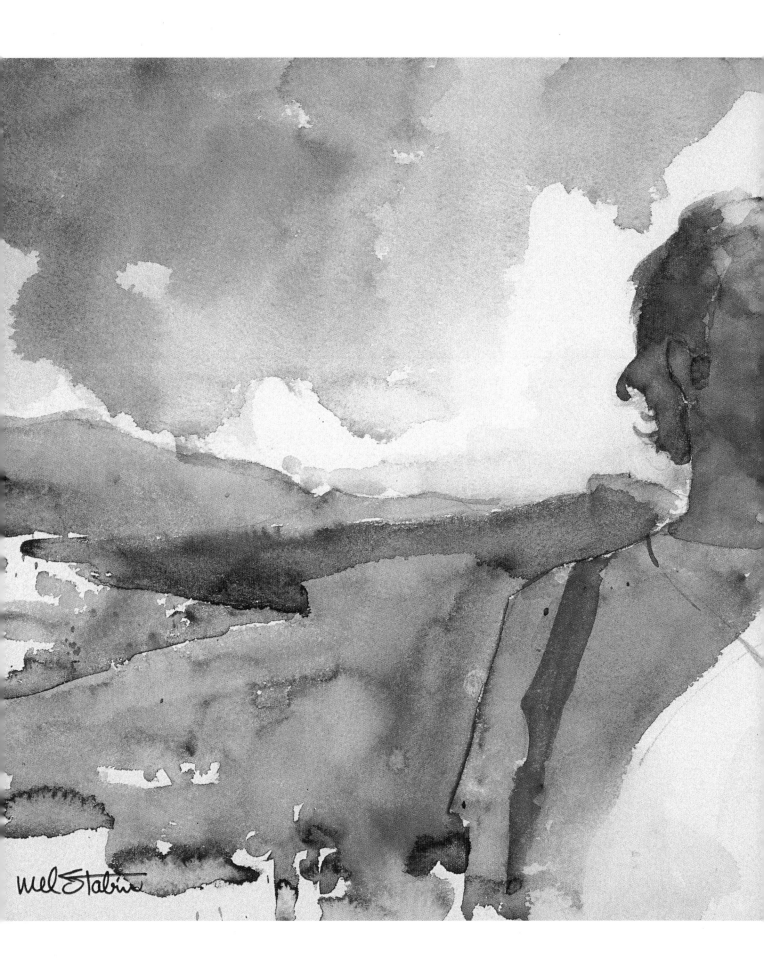

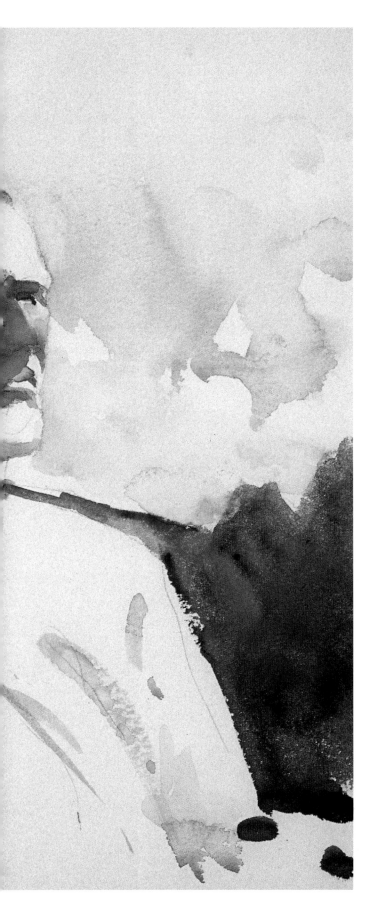

Light and Shadow

"You can't depend on your judgement when your imagination is out of focus."
—MARK TWAIN

Form is described by light and shadow. The secret to describing the form of the figure is to follow the shapes created by shadow. If you paint the shadow shapes accurately and treat the edges correctly, the light on the figure will magically appear.

One way to create a sense of strong light in a portrait is to use contrasting values. Another way is to maintain luminosity and transparency in the shadow area. "Open" or very transparent shadows with rich color changes indicate reflective light bouncing back into the shadow area.

Mountain Man, 11 x 15" (27.5 x 37.5 cm)
Collection of Ira and Joan Wallace

A Day with Jesse

I attend open sketch class at a local art association every week, when I'm not traveling around the world conducting workshops. I've been sketching and painting there for years with fellow artists whenever I have the time. "A Day with Jesse" shows the various stages of a typical session with a model, beginning with quick sketches to painting figures to a final portrait.

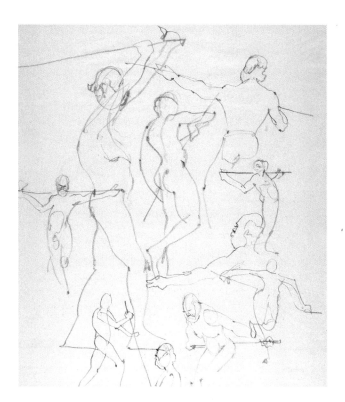

17 x 15" (42.5 x 37.5 cm)

A series of one-minute sketches with a 4B pencil.

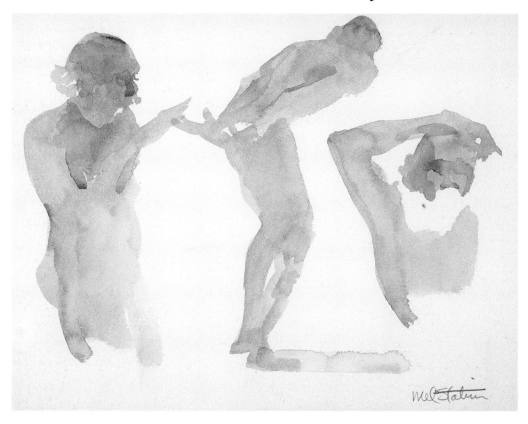

11 x 15" (27.5 x 37.5 cm)

Two-minute figures. I painted directly, blocking in the figure with one color. No sketching was done.

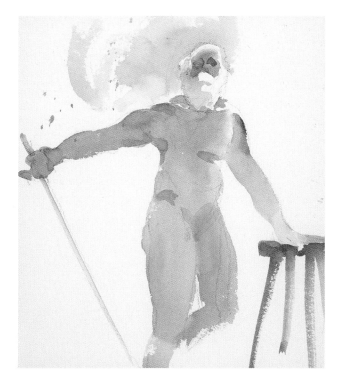

RIGHT: 15 x 12" (37.5 x 30 cm)

A ten-minute pose executed with a limited palette. A strong light shines on the side of the face.

BELOW: 15 x 22" (37.5 x 55 cm)

Two twenty-minute sessions of the same pose. The light on Jesse was isolated to his cheek and abdominal muscles. The rest of the figure is midtone with darker midtones defining form in the shadow area.

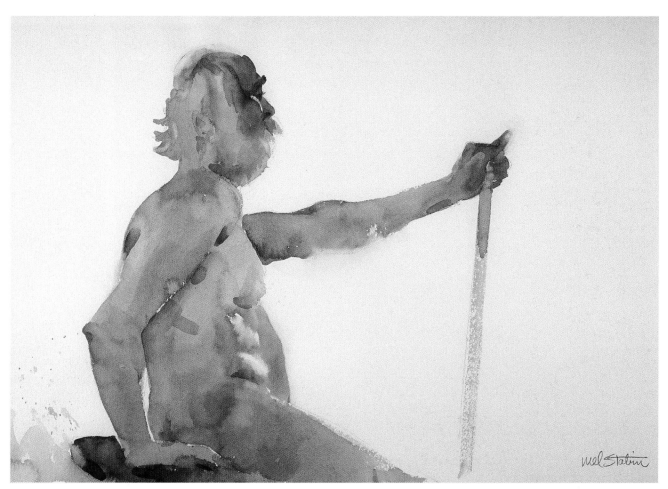

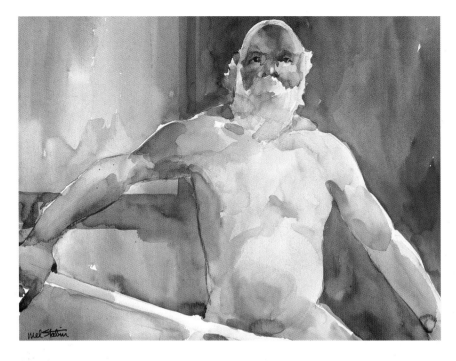

ABOVE: 15 x 22" (37.5 x 55 cm)

In this painting, I gave consideration to the background. Jesse has a well-defined body and I tried to indicate his form and muscles with a minimum of brushstrokes.

BELOW: 15 x 22" (37.5 x 55 cm)

Here Jesse is mostly realized as a silhouette. The overhead light was indicated using the white of the paper, defining the spine, buttocks, hip, shoulder, and the length of his outstretched arm. Note that the white shapes were hard-edged except for the area of the shoulder blade. Small areas of light, if kept hard-edged, gives "snap" to the painting. My palette consisted of Raw Sienna, Winsor Red, and Sap Green.

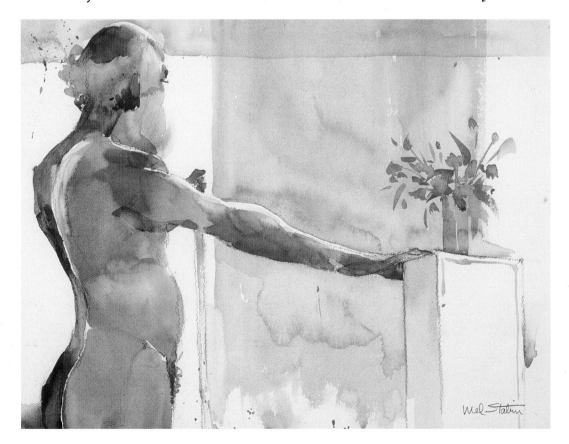

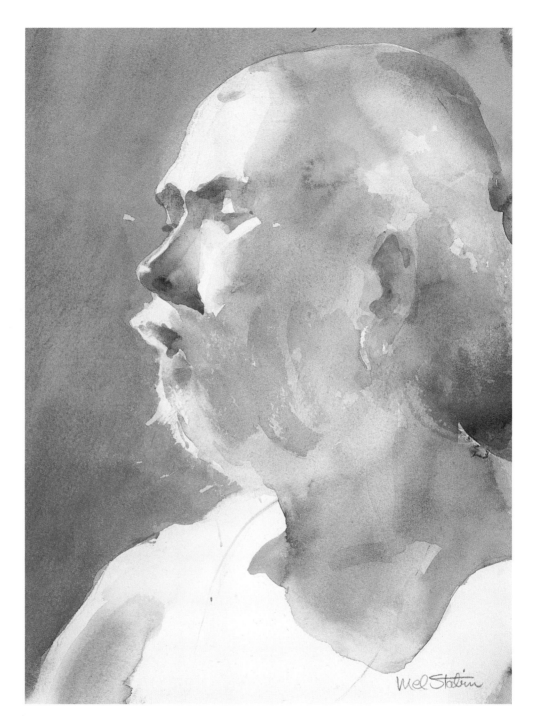

22 x 15" (55 x 37.5 cm)

The color scheme in this portrait consists of Raw Sienna, Cobalt Blue, Winsor Red, favoring the compliment of purple and yellow. The first wash on the face was one continuous shape of the head, hair, beard, eye socket, and nose. Second washes with color and value changes were then applied to describe form and texture. The beard, hair, and neck colors blend together in the shadow area, thereby directing the eye to the more pronounced area of the features.

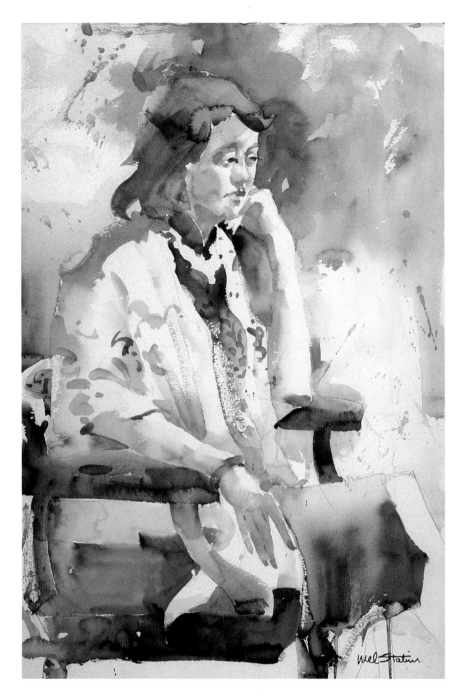

Silk Blouse, 22 x 15" (55 x 37.5 cm)

There are essentially three large value areas in this painting: the white of the paper represents the light on the model; the midtone values occur in the background, skin, and silk blouse; and the darks are seen in the chair, upper section of the dress, and the hair. Though there is a lot of activity in the colors and brushstrokes, the painting is not chaotic because I kept the three value areas simple and distinctive.

OPPOSITE

Shady Ladies and a Gentleman 15 x 22" (37.5 x 55 cm)

The white of the paper was used to indicate the strong sunlight on the gentleman, the vertical support in the foreground, and the boardwalk. A midtone value of warm and cool purples was used for the ladies and the structure of the pavilion in the background. Note in the shadow areas how the shapes fuse.

Uptight, 15 x 22" (37.5 x 55 cm)

Combining shapes rather than isolating shapes is always preferable. The shadow shape of the hair, side of the face, neck, chin, and cast shadow on the shoulder is indicated with one continuous wash.

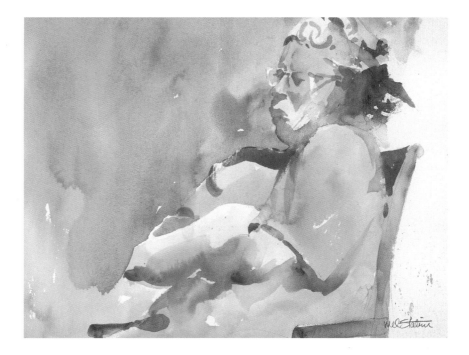

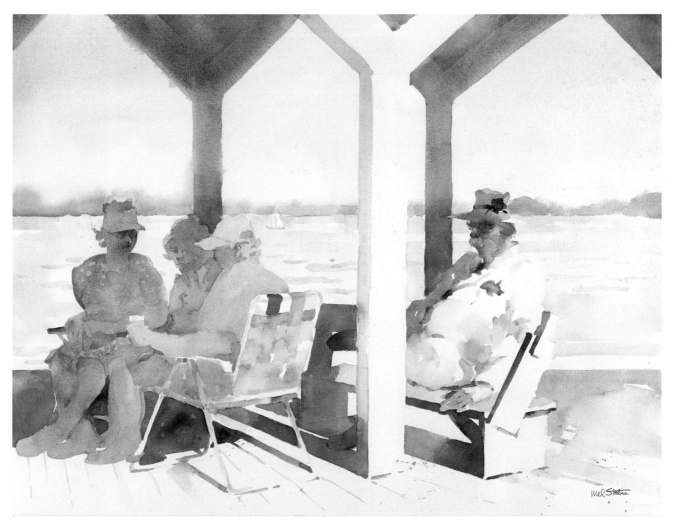

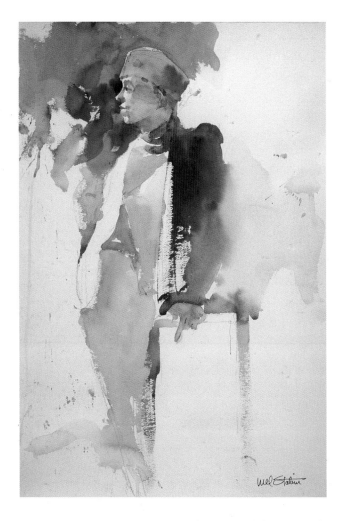

LEFT: *Purple Hat*, 22 x 15" (55 x 37.5 cm)

It was important to paint the face accurately, since this was the area of interest. The clearest description of form is of the face and hat. Everything else is treated as shapes of color and value with a variety of brushstrokes. The light coming from the left creates the sharp-edged contrast. The face and jacket contrast with the background.

BELOW: *Relaxed*, 15 x 22" (37.5 x 55 cm)

The fewer shapes in a painting, the better. The shadow shapes of the face dissolve into the background and into the turban. The cast shadow along the shoulder fuses with the shape of the choker and continues down the dress, changing color en route.

Simplifying all the shadows into a single shape was the objective. The darkest dark (the choker and top of turban) is seen against the lightest light. That is the primary interest of the painting.

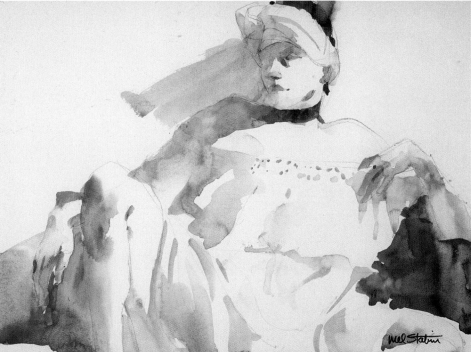

Apprehensive, 22 x 15" (55 x 37.5 cm)

Here harmony is created by repetition of colors in varying intensities. I applied a light warm wash of Pale Yellow Ochre and Cadmium Red light to the face and hands. For the jacket and pants, I used a light gray, flavored with warm and cool colors. When these washes were dry, I applied second washes.

Cadmium Red Light, Raw Sienna, Winsor Red, and Cobalt Blue comprise the midtone value of the shadow on the face. Part of the front leg blends into the background. The midtone value of the background was put in last as a contrast to bring out the light side of the face. The background is essentially the same value as the jacket, but is filled with echoes of the colors that appear throughout the painting.

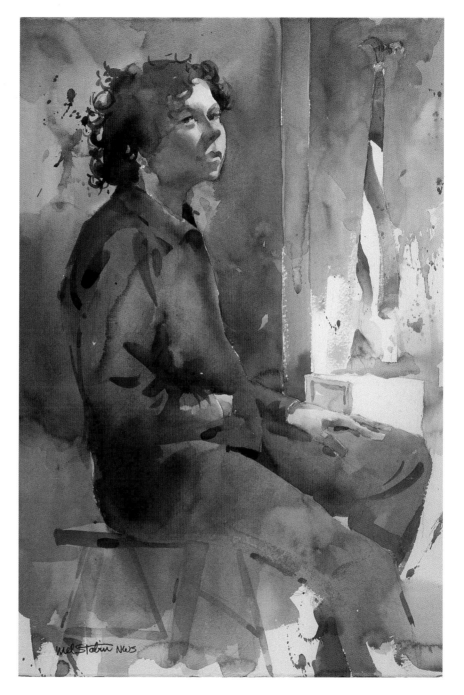

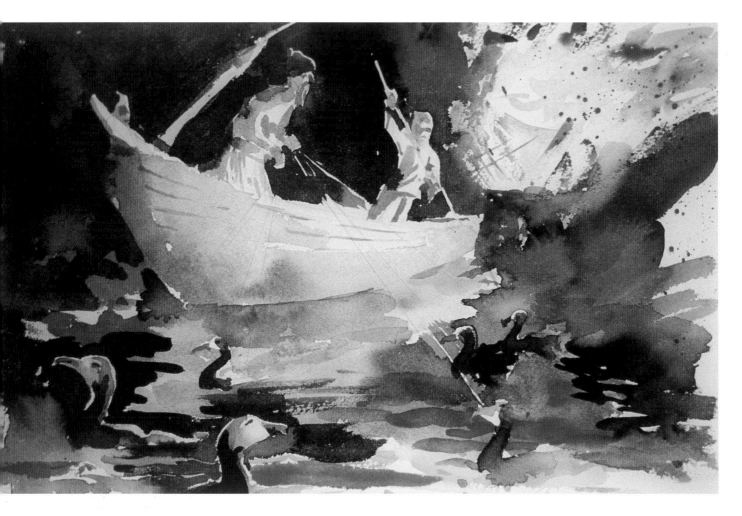

Fishing Cormorants, 11 x 15" (27.5 x 37.5 cm)
Collection of Mr. Ito

I painted this from memory in forty-five minutes the morning after an exhilarting event in the Japanese province of Gifu, where training cormorants to dive for fish is a tradition. When painting from memory, the primary focus is to hold onto the "impression" of the subject, with detail being secondary.

The flickering, brilliant lights created a very dramatic high-contrast scene. In this artificial light, silhouettes became very pronounced. This painting is more concerned with value relationships than color.

Raquel, 15 x 11" (37.5 x 27.5 cm)
Collection of Candida Gonzales

Front lighting is more flat, and lacks the drama of side lighting. Nevertheless, a painterly quality is achieved by creating a balance of hard and soft edges. Subtle contrasts indicate the forms of Raquel's features, the cast shadow on her neck, and the soft shadows on the body.

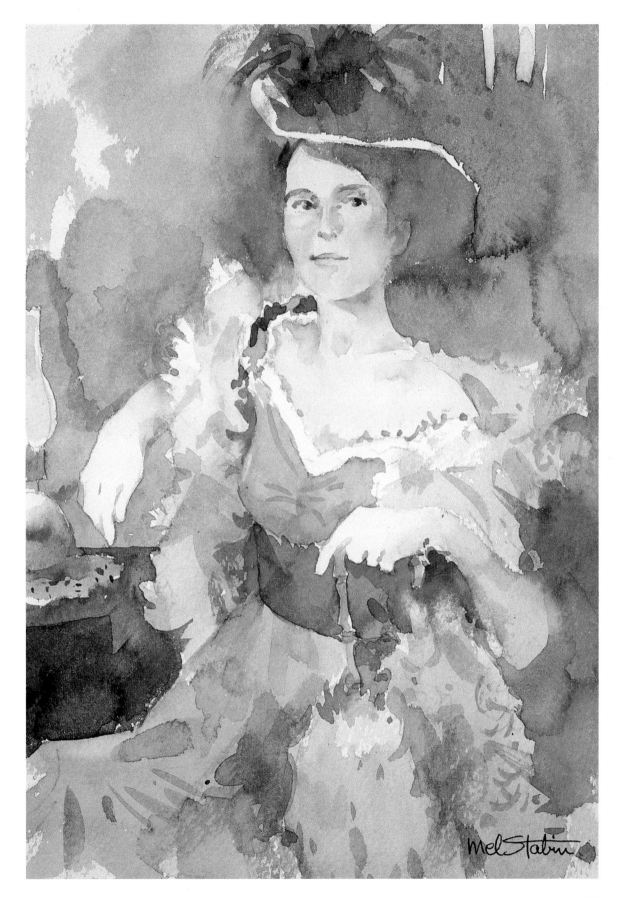

Red Turban

1. This series of steps demonstrates how to simplify a figure by using a minimum of brushstrokes, glazing, and combining shapes with continuous washes. A quick sketch with a 4B pencil begins the process. Some of the linework is long and curvy as shown from the shoulder to the buttocks. Some of the lines are straight.

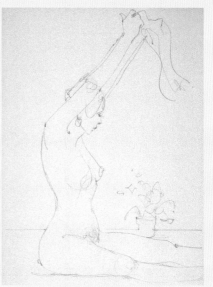

2. I lay in a continuous wash of the shadow shape, changing color as I go. The colors include Raw Sienna, Cadmium Red, and Cerulean Blue. The light side of the figure is the white of the paper. I soften some of the edges of the wash where the shadow meets the light area. Some edges are untouched and remain firm.

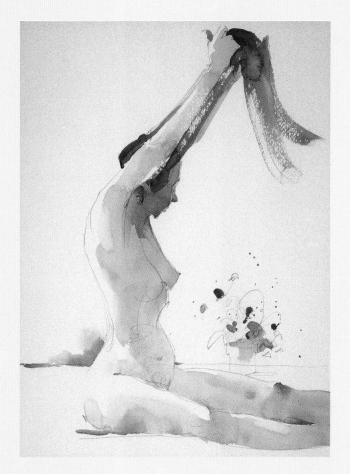

3. A couple of quick brushstrokes of Alizarin Crimson describe the red turban. Moving the brush quickly across the surface of the paper creates the dry brush effect. I begin a second darker wash of the skin color for the face in shadow. The light Cerulean Blue is substituted with Cobalt Blue. Some hot pink and green is splashed on the plant. I continue the shadow wash from the face down to the breast and also darken the value of the legs.

4. The light horizontal platform is defined by the darker background. The darker area of the background to the left brings out the light area on the model. Finally, some quick dabs and splatter of pinks, green, and yellow completes the plant and pot and the painting.

Red Turban
15 x 11" (37.5 x 27.5 cm)

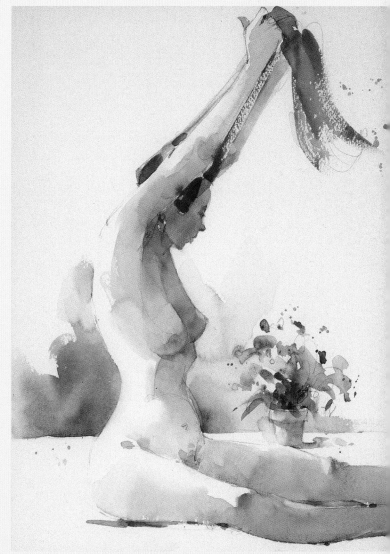

Treating Edges

*An artist has to be able
to cut a great deal away."*
—EDGAR DEGAS

The use of "lost" and "found" edges is a classical method of painting and can be seen in great masterpieces, such as a Michelangelo or a Vermeer. A painterly quality occurs when a variety of edges are used.

To a great extent, the illusion of light falling on a figure depends on how the edges of the shadow shapes are treated. The treatment of edges helps to create emphasis in some areas and reduce emphasis in others. Hard-edged shapes demand attention, soft-edged shapes do not. So take advantage of highly contrasting shapes to create the area of interest.

Yellow Scarf
11 x 15" (27.5 x 37.5 cm)

Three Kinds of Edges

Your brush can make only three kinds of edges: a hard or "found" edge, a soft or "lost" edge, and a dry brush or "broken" edge. How and when to make these marks is crucial in describing form. By squinting hard at the subject, you can determine which shapes are soft-edged and which are hard-edged. A hard edge is usually employed in an area that demands attention. A soft edge demands less attention (as in murky shadow areas as opposed to sharp, contrasty areas). Soft edges can integrate shapes, which helps to create unity throughout a painting. A dry-brushed edge is a broken edge that can suggest detail.

A good rule to follow is cast shadows are always hard-edged; form shadows, on cylinders or curvilinear shapes, are always soft-edged.

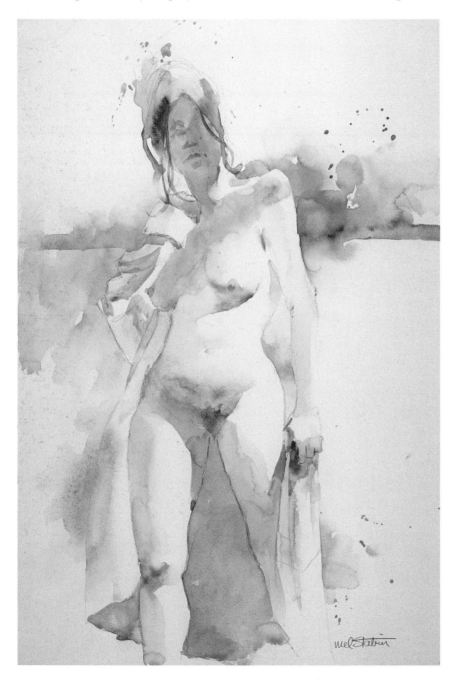

Tall Gal, 22 x 15" (55 x 37.5 cm)
The features of the face were kept very quiet to give emphasis to the play of light on the body, which is the main area of interest. As you can see, light softly fades into shadow on this form, but the cast shadow of the breast is hard-edged until it folds into the light wash of the torso. As the pale shadow of the torso goes into the light, the edge of the shadow is softened. The shadow on the right leg, cast by the left, is hard-edged and follows the cylindrical shape of the leg.

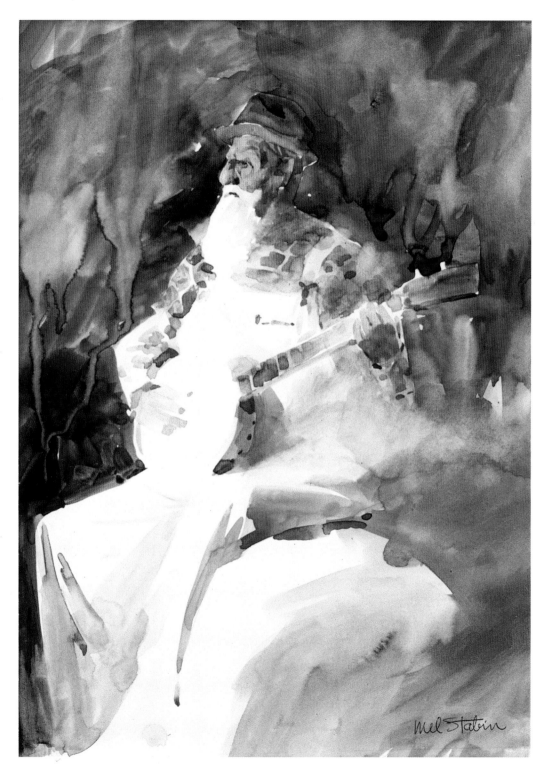

Banjo Man
15 x 11" (37.5 x 27.5 cm)

To emphasize the sense of strong light on the figure, I connect-ed the white of the beard to the overalls, banjo, and leg. I also exaggerated the connections made in the shadow area by dis-solving the shadow of the figure into the background, thereby emphasizing the center of interest—the face and the banjo.

The Mask Maker, 30 x 22" (75 x 55 cm)

A soft edge allows the multicolored garment to blend into shadow and join the shape of the seat. The mask maker's hair also fuses with the cast shadow on her shoulder, creating the illusion of one shape rather than two.

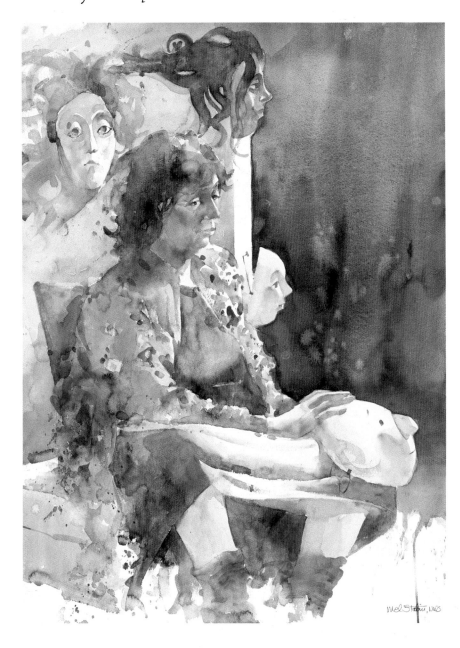

OPPOSITE: *Sunday at the Pub*
15 x 11" (37.5 x 27.5 cm)
Collection of William Skoros

The intricate form of the table legs fuses into the dark background. This deliberate integration of the table and background creates interest in the area that is the focus of the painting: the figure. The sharpest contrast occurs in the face and the light of the newspaper. Save contrasting values for the important areas of interest. Blur the less interesting areas.

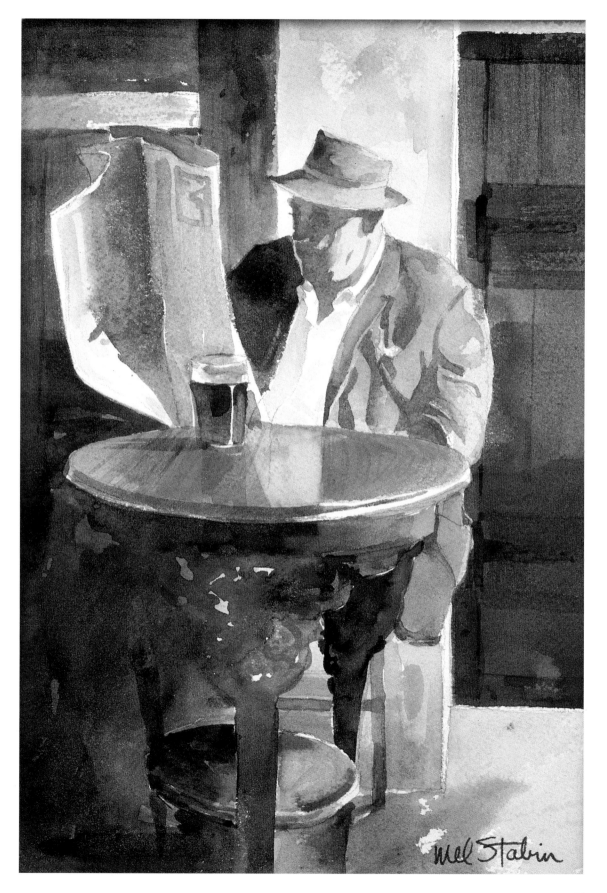

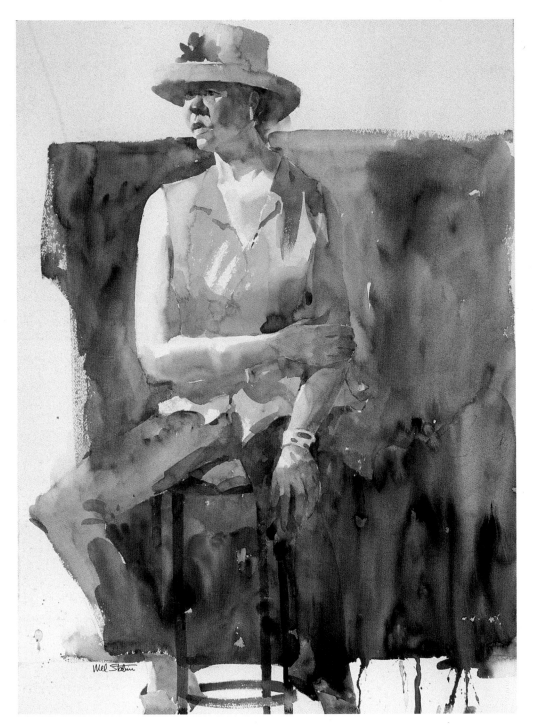

Pink Flower
30 x 22" (75 x 55 cm)

*I wanted the focus to be on Tammy's face and upper body, so I empha-
sized areas with strong silhouettes, exciting color, and a variety of edge
treatments. The light side of her right arm and shoulder forms a sharp
edge against the dark background, while the shadow of her left arm is
lost into the shadow of the blouse, and the pants are blended into the
background. I treated the background as an abstract shape with some
interesting color and resisted describing folds and forms in the fabric.*

TOP: *Laverne,* 15 x 22" (37.5 x 55 cm)

The treatment of edges helps to create emphasis in some areas and reduce emphasis in other areas. It also allows the figure and background to intermingle with each other, which helps to create unity throughout the painting. In this painting, there are hard edges, broken edges and soft edges. The mid-tone background behind Laverne is hard-edged, focusing attention on her shoulder. The hat creates less attention because it is very close in color and value to the background and has both "lost" and "found" edges. The shadow of the near leg is blended into the cast shadow. The light on the back leg is emphasized by the hard-edged washes behind it. Notice the changing character of the washes behind the leg in color, value, and brushstrokes.

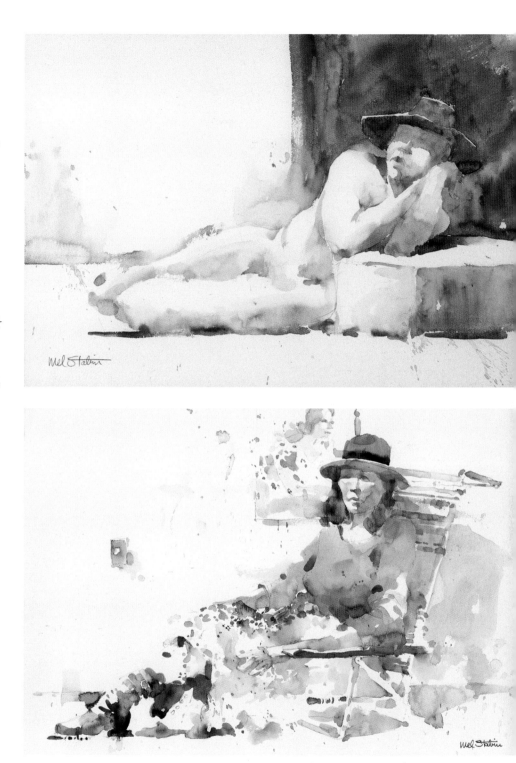

BOTTOM
Orange Hat, 15 x 22" (37.5 x 55 cm)

The dark shape of the hair creates a firm edge on the light side of the face. Its outside edge blends into the picture on the wall. The design of the skirt suggests the form of the figure, fading into the background in the lightest areas. The hair in shadow and the lower area of the shoulder are fused into the cast shadows on the chair. There are various ways to treat edges. Your choices depend on how the light plays on the figure, but be innovative when you can.

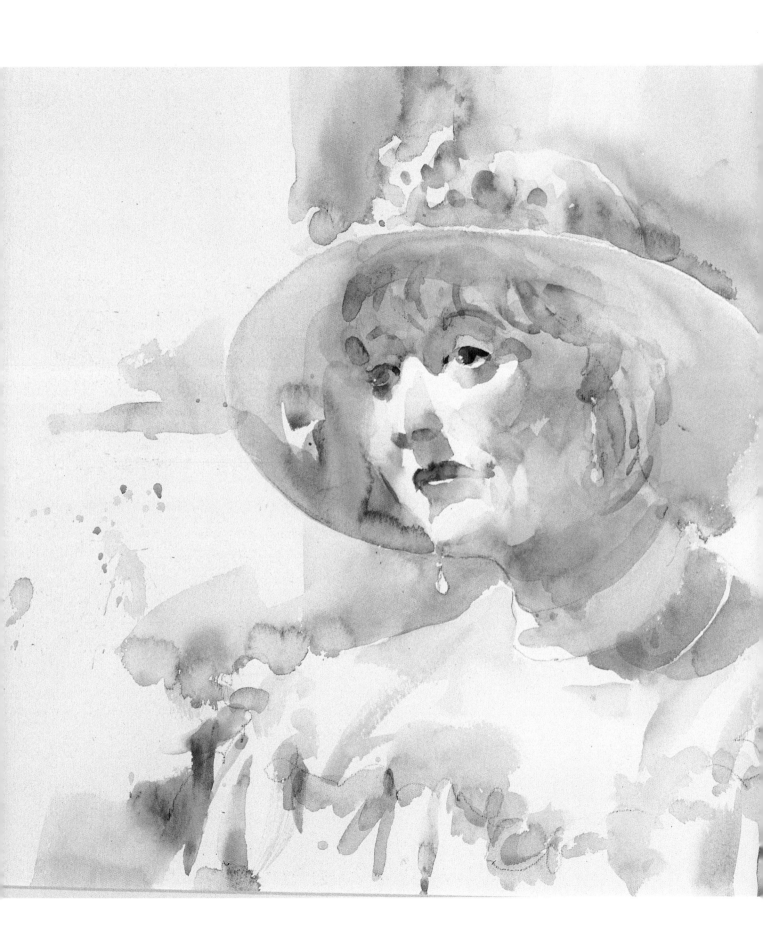

Painting Portraits

"Work with great speed...get the greatest possibility of expression in the larger masses first. Do it all in one sitting if you can. In one minute if you can."

—ROBERT HENRI,
American painter (1865–1929)

The character of a person is seen in the underlying structure of the face. An understanding of the underlying structure is necessary in order to paint portraits well. Facial features and their relationship to each other are dependent upon what occurs beneath the surface.

A Beautiful Woman
15 x 22" (37.5 x 55 cm)

Facial Structures

Features should not be thought of as being "on" the face, but rather as "part of" the face. Every feature has dimension and form, and has its place as "part of" the skull, and is in relationship to each other. Features are described by the way light falls on them.

This chapter will expound on painting "expressive" portraits by working from the inside out. Emphasis will be on simplifying shadow shapes, color and value relationships, and proportions.

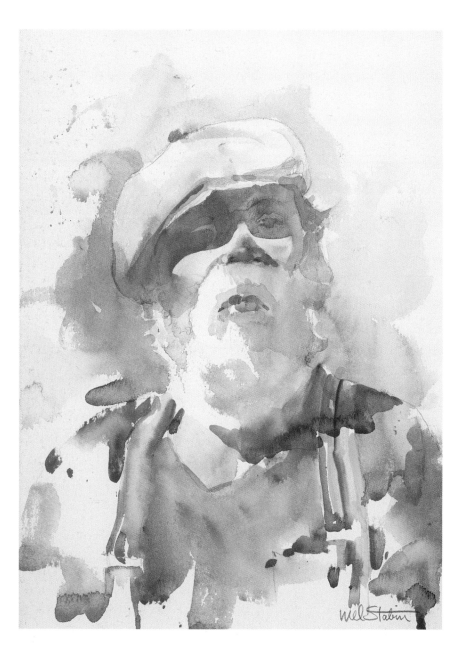

Grey Beard, 15 x 11" (37.5 x 27.5 cm)

Different edges combine to sculpt this face. The cast shadow of the cap follows the planes of the face and is hard-edged. Note that the shadow across the cheek is softened as it goes into light. The shadow of the cheek is soft-edged because it is describing the soft form of the cheek.

OPPOSITE

Baseball Cap, 15 x 11" (37.5 x 27.5 cm)

I simplified the shadow shape of the face by having one continuous wash describe its contours. Edges were treated while the wash was wet, which is best because it is very difficult to soften an edge after the wash dries. The edge is soft at the cheek and firm in the hollow of the eye, the lower eyelid, and the cast shadow of the nose.

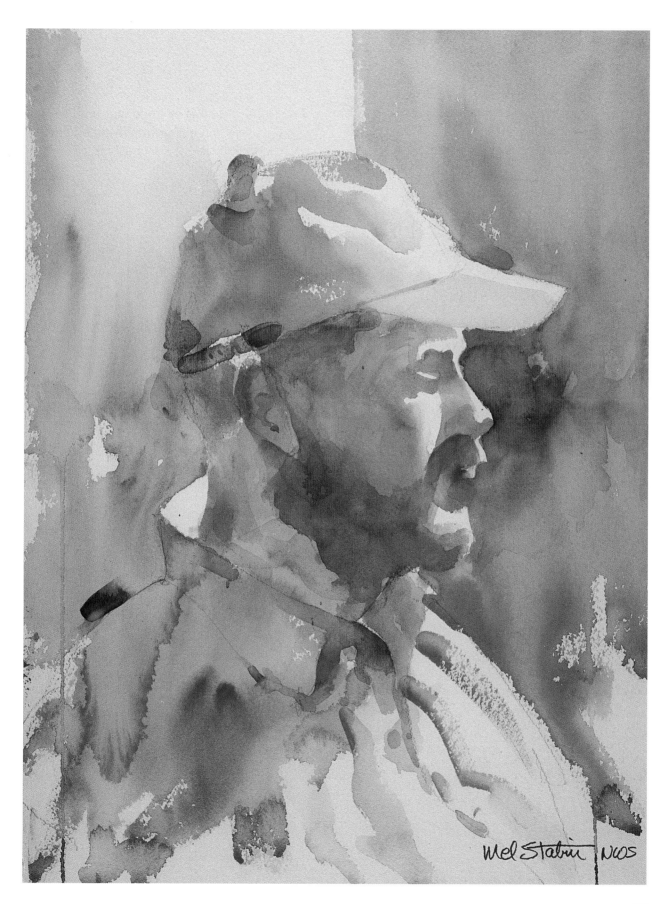

Strong Light, 15 x 11" (37.5 x 27.5 cm)

Here the sense of light is conveyed through luminous and transparent shadow areas, with rich color changes. This gives the appearance of light bouncing back into the shadow area. It can be seen under the chin, under the nose, and in the eye sockets. Note that the pupil and lids of the eyes are conceived as part of the structure of the eye socket.

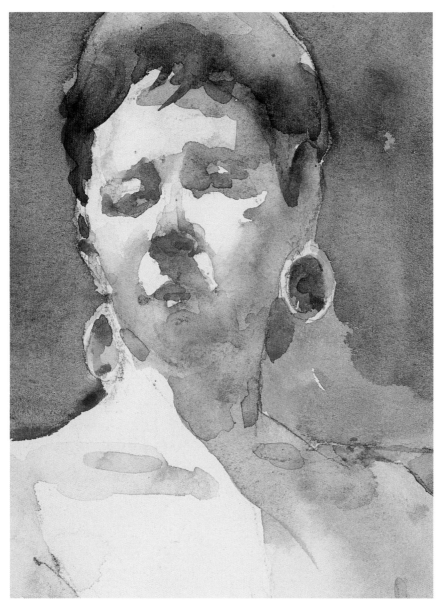

OPPOSITE

Wild Hair, 15 x 11" (37.5 x 27.5 cm)

This was a 20-minute painting of a fellow artist whom I paint with in sketch class. The first wash of Raw Sienna covered her great mane of hair and interesting face. Rapid brushstrokes, applied once, described the wildness of the contour of the hair. The wash of the face softly blends into the purple turtleneck and the black collar. When these washes dried, I described the features with a second wash of Cadmium Red on the cheek and Raw Sienna on the hair for some definition.

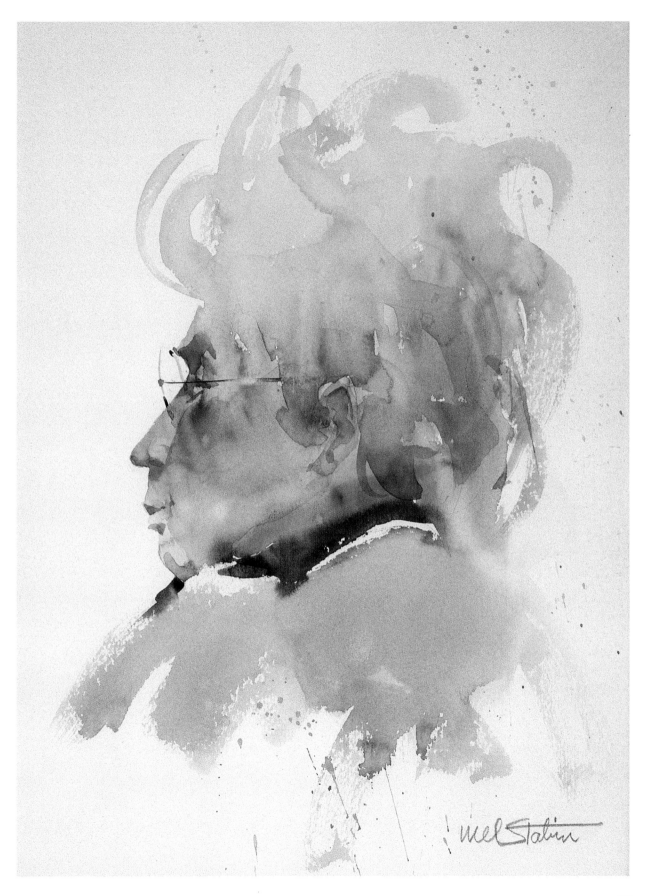

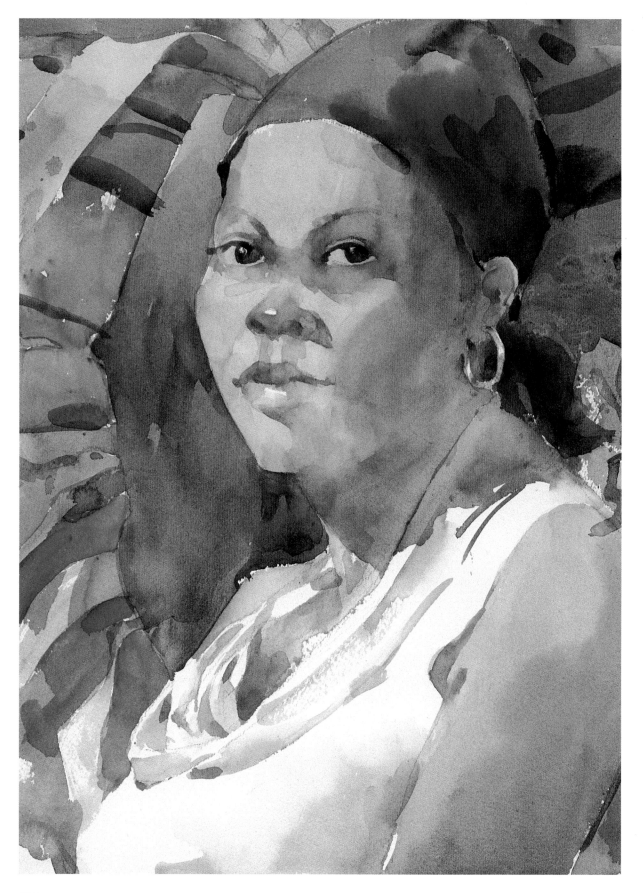

Tammy, 15 x 11" (37.5 x 27.5 cm)

Tammy was a delight to paint. She has a lovely face, especially the eyes. For her honey-colored complexion, I used Raw Sienna, Cadmium Red Light, Winsor Red, and Sap Green. I exaggerated the green in the shadow area to suggest a strong reflection from the green leaves behind her. Painting the background a dull green purple formed the light side of the face.

I asked an artist next to me if my painting looked a little like Vermeer. She said, "I don't think so. Vermeer had a moustache."

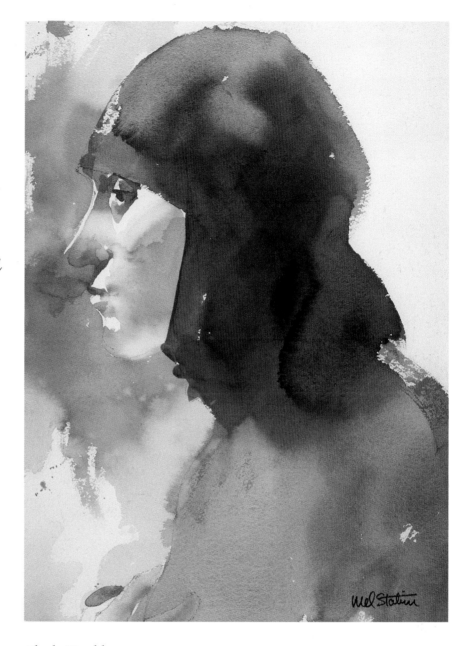

Black Headdress, 15 x 11" (37.5 x 27.5 cm)

The facial features and black headdress reveal the essence of this person's character. The sharpest edge of the dark headdress is seen against the light shadow of the cheek. I intentionally played down the strong profile by repeating the colors of the skin in the background, thereby giving greater prominence to the shapes created by the light on the face and the black headdress.

Thinking

My approach in painting is pretty consistent regardless of subject matter. I look for the large masses of color and value before I begin. Then I describe these shapes as quickly and simply as I can, without concern for the small details.

1. I began this painting with a simple pencil drawing on 140-lb. cold press paper.

2. I blocked in the basic shadow shape of the face, changing color en route. The colors used were Winsor Red, Raw Sienna, and Cobalt Blue. A light wash of dull blue/purple (made of Cobalt Blue, Alizarin Crimson, and Payne's Gray) was allocated for the dress.

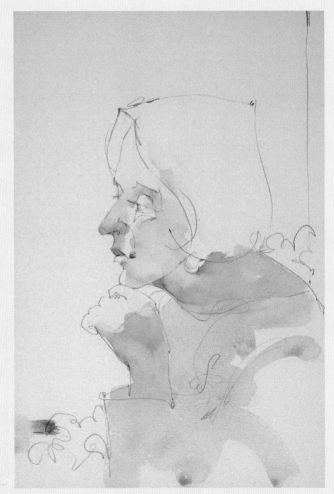

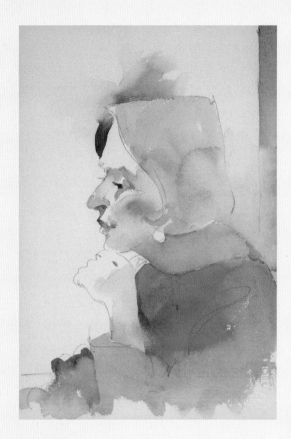

3. I continued to describe the form of the features by treating edges and adding cast shadows below the eye and nose. A light wash of raw sienna was used to describe the shape of the hair. A warm dark value described the hair next to the forehead and brought out the contour of the face.

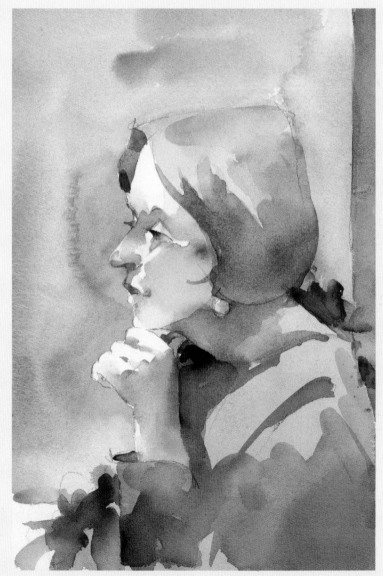

4. Next, I described the form of the hand. The red boa was added as well as some shadow shapes in the hair and dress. Finally a midtone value was added to the background and the painting was finished.

Thinking, 15 x 11" (37.5 x 27.5 cm)

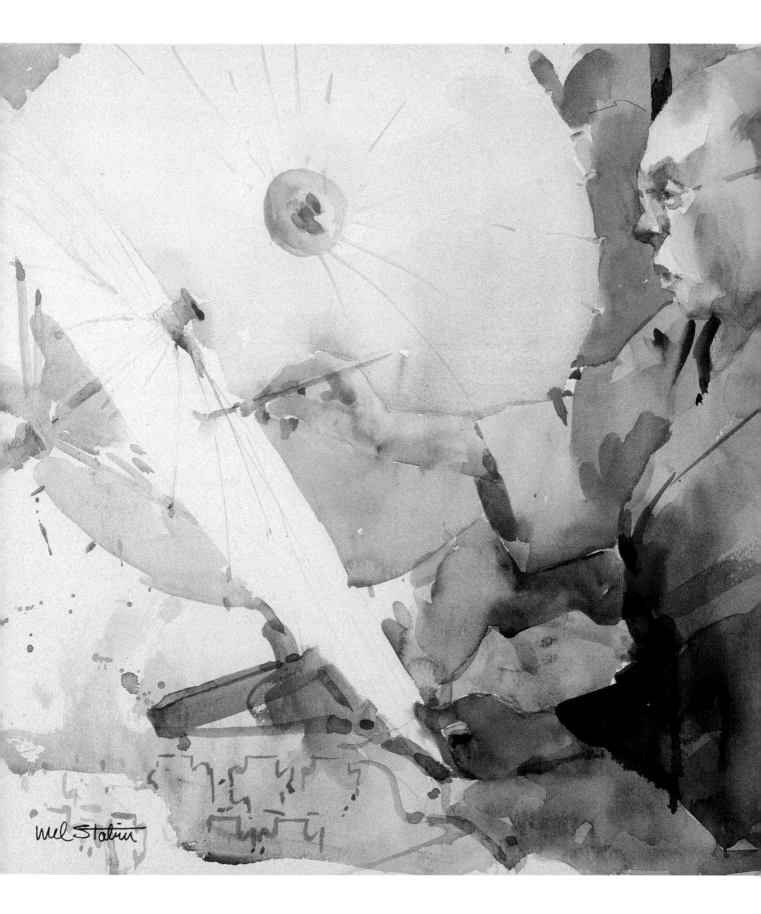

Painting People in an Environment

"The sketch is probably better. Lots of times they are."

—OGDEN PLEISSNER,
American painter (1905–1983)

Painting people in a real environment is always an exciting adventure. Individuals as well as groups of people are attractive subjects. People seldom stand or sit for very long. This is all the more reason for simplifying, painting quickly, and being focused on the essence of the subject.

It should always be the essence, your impression, your reality, that you are after. The facts of the subject are there as support for your idea. You can accept or reject them...and you should.

Umbrella Maker of Yamagata
15 x 22" (37.5 x 55 cm)

Composition

Composition is the first thing to consider when painting people in an environment: where the figure or figures reside on the paper, the size and shape of these elements, and their relationship to the environment.

When I begin a composition for a painting, I focus on dividing the rectangle of the paper into broad, simple areas of vertical, horizontal, and diagonal shapes suggested by the subject. I lightly pencil in these shapes and when I am satisfied with their place-ment, I draw in the figure(s) and the environment. Creating a dominant color, value, shape, and direction in the composition are also important considerations.

Don't let anything get in the way of your impres-sion of the subject. What attracted you to the sub-ject? What will be the "idea" of the painting? These are questions that you should ask yourself before you begin to paint. One of the most important deci-sions to be made in any painting is deciding on what to omit from the painting. Include only those details and elements of the subject that contribute to your objective for the painting. Ruthlessly eliminate any element that contributes nothing.

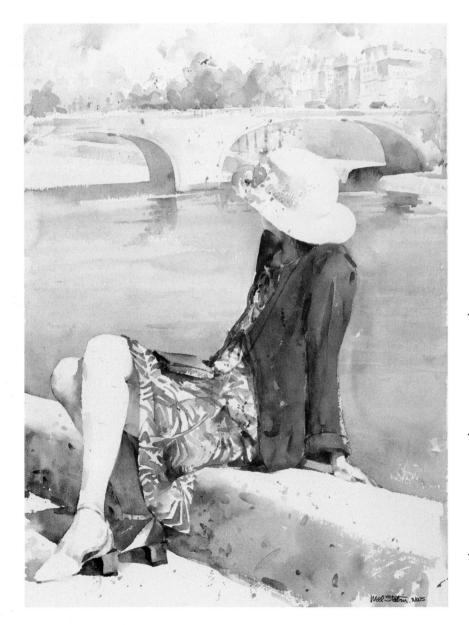

Paris, 30 x 22" (75 x 55 cm)

This lovely, long-legged woman symbolized "Paris" for me. In reality, the figure was silhouetted against the dark shadow under the bridge. I wanted to paint the open, bright feeling of the day, so I borrowed a view from further down the river. The composition became more dynamic by introduc-ing the diagonal bridge, which relates to the diagonal of the low wall on which the figure sits. The figure connects the two diagonal shapes, thereby creating a path for the eye to follow.

Jim, 15 x 22" (37.5 x 55 cm)

The environment was very rich in texture and detail, but I resisted the temptation of painting it all. I indicated a few of the stones on the wall and the old wood farm door. My focus was on the figure.

The vertical shapes of the figure and the door were connected by the strong diagonal cast shadow, which resulted in a well-designed composition.

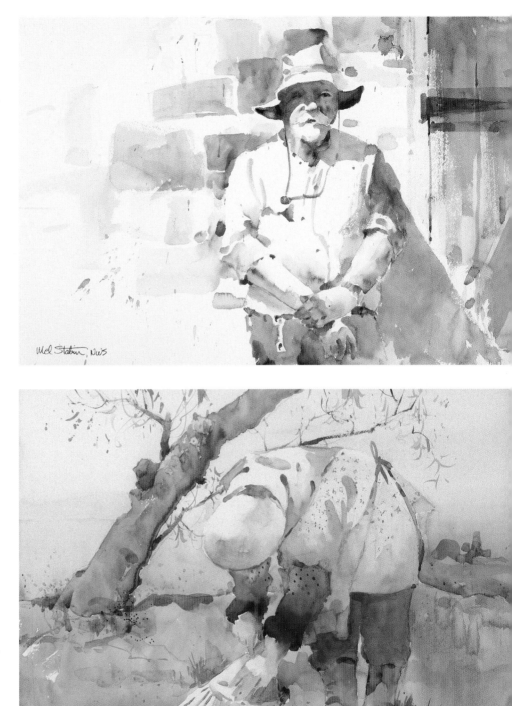

Temple Gardener, Kyoto
15 x 22" (37.5 x 55 cm)

The three shapes that I made much of in this painting were those of the gardener, tree, and the mossy ground. I dismissed the background completely with a simple, gradated wash of gray. This gray/blue color is repeated in the description of the headdress and blouse on the figure and is a foil for the intense colors of the tree and ground.

Spanish Village, 15 x 22" (37.5 x 55 cm)
Collection of Diane Krasner

I simplified the composition of this painting to three major shapes: the horizontal shape of the buildings, the horizontal shape of the sunlit ground, and the vertical shape of the figure. There is a dominance of warm colors. The purple blouse on the figure is the strongest value, balanced by the darks of the palm tree and plants at the left of the painting. The pattern on the skirt is suggested, not rendered. Note that I "lose" the skirt by blending it softly into the background on one side. Part of the straw hat is also lost into the background. This fusing of shapes helps to unify the figure and the environment. Unity is the primary consideration for aesthetic order.

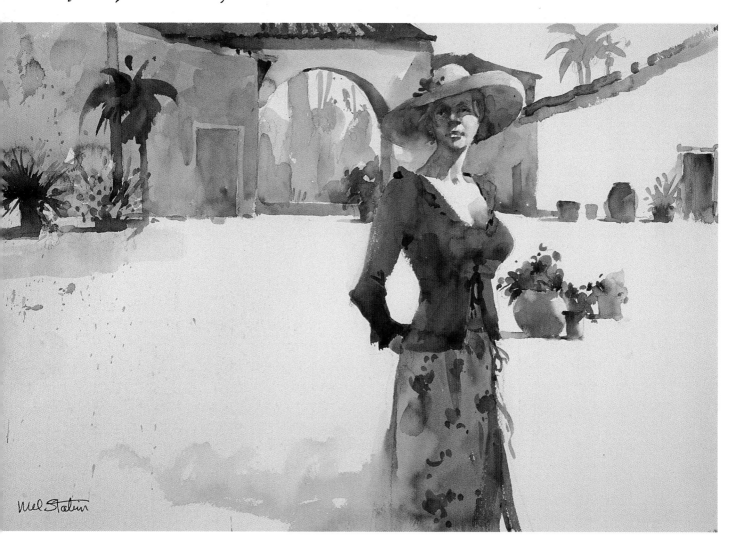

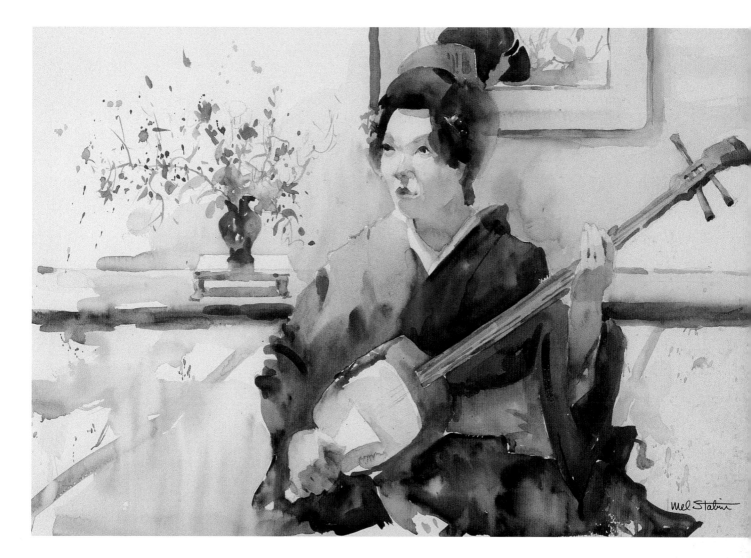

Geisha, 15 x 22" (37.5 x 55 cm)

During one of my workshops in Japan, I tried to capture the mystique and grace of this Geisha playing the lute. The dominant shape of the figure connects to the low horizontal table and to the framed painting in the background. The few intense areas of color in the barrette and decorations in the hair, the sash around the waist, and the red pillow added some color excitement and contrast to the larger neutral areas. The small flower arrangement added to the atmosphere.

In this painting, a dominance of wet, fused washes can be seen in the figure and the environment.

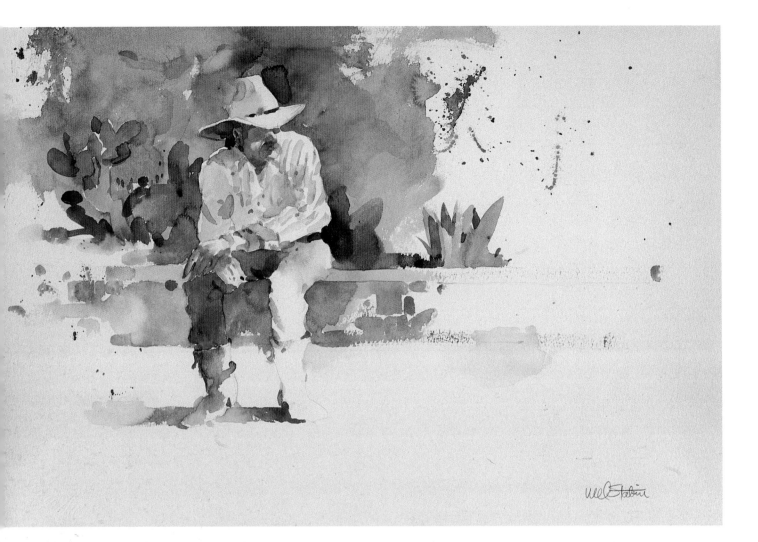

Siesta, 15 x 22" (37.5 x 55 cm)

This vignette was painted very quickly on a hot day in San Miguel, Mexico. I had to finish painting from memory because the man arose to leave. The large areas of white on the paper and the quiet attitude of the figure contributed to the feeling of a hot day. Note the different treatment of the man's legs and boots. Detail should be suggested in either the light area or the shadow area of a shape, but not in both. Here the stripes appear only in the light area. The simple shadow shape of the face merges with the dark shadow of the hat.

Chris in St. George's, 7 x 10" (17.5 x 25 cm)

I always carry a sketchbook with me to "capture the moment" when it presents itself. The small light areas seen against the large midtone and dark values caught my attention. The light midtone values of Chris's shirt and paints are very close and are described with lost and found edges.

The composition helps create a center of interest in two ways: the horizontal wall is interrupted by the vertical shape of the figure; and the hat, face, and shoulders contrast against the dark foliage in the background.

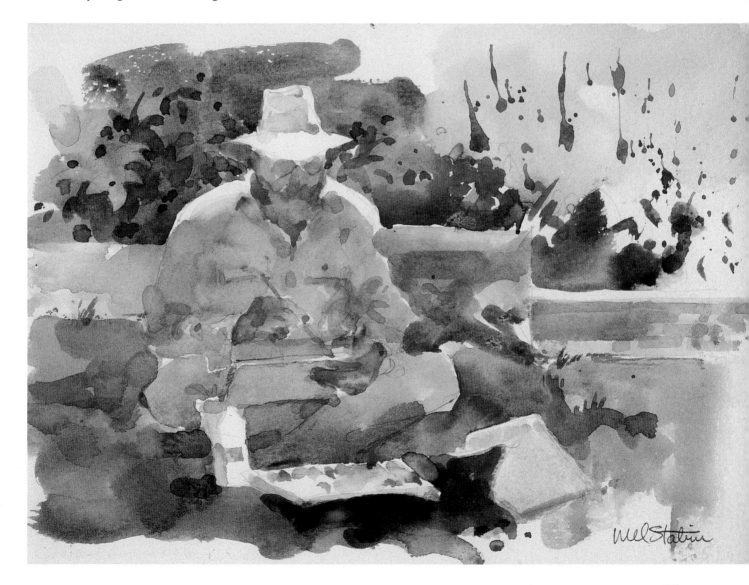

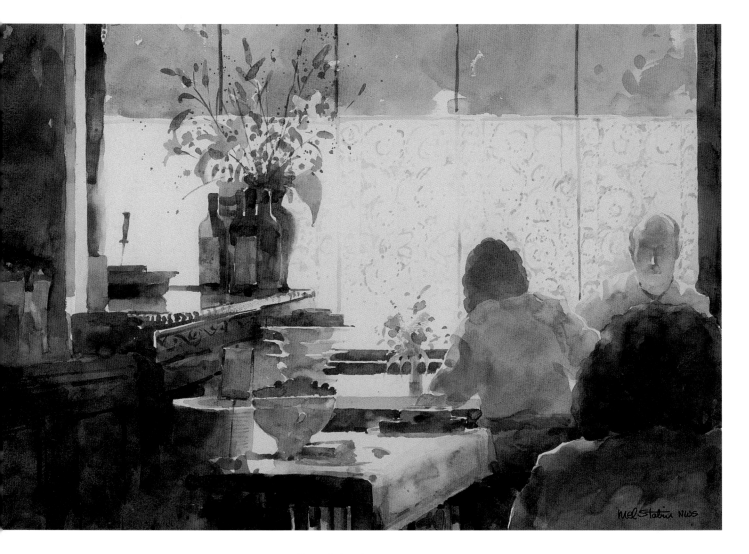

Lunch in Auvers, 15 x 22" (37.5 x 55 cm)

The light shining through the white lace curtains of this old restaurant created a strong pattern of exciting, silhouetted shapes. Because of the strong backlighting, value is more important than color. The dark wood of the bar, paneling, and tables were hardly distinguishable.

The figures were composed in a receding perspective against the lace curtains. Wet-in-wet juicy washes were used to describe the dark values of the figures and tables seen against the contrasting light values of the lace curtains. Van Gogh lived in a very small bedroom above the restaurant.

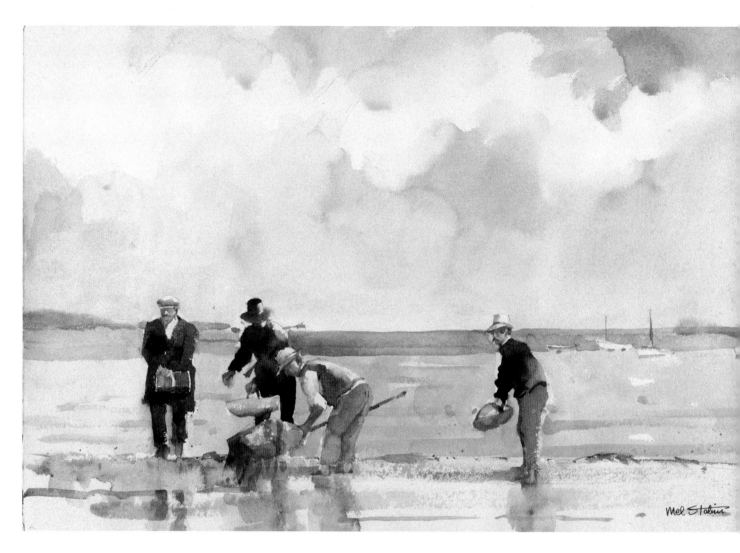

Clam Diggers in Ile de Ré, 15 x 22" (37.5 x 55 cm)

I used a black-and-white New York Times *photo of these figures for reference. The cloudscape came from my imagination.*
I kept the figures dominant in value but small in size. The way the figures are arranged has a rhythm. Variations in the space division of water, beach, sea, and sky are also evident.
The environment is important to the mood the painting conveys.

Morning on the Dunes

1. I used a simple composition comprising three horizontal shapes of sky water and sand with variations in their dimensions. The vertical figure creates contrast to these rhythms. A quick drawing of these elements was done with a 4B pencil.

2. Using a #14 round Kolinsky, I applied large areas of wet pale washes of Yellow Ochre, Cerulean Blue, and Alizarin Crimson to the sky and water and allowed the colors to fuse and play with each other. I let the water mingle with some of the warm sand color and dropped in some ochre on the straw hat with a touch of intense orange and pink for the flower.

3. I quickly applied a midtone wash of warm colors starting with the face continuing into the cast shadow across the shoulder and down the arm. While the wash was still wet, I softened the edge of the lower arm so that it integrates with the sky and joins the wash of the shadow of the skirt. The flower at the figure's neck was indicated, and a few quick thrusts of the brush were used to describe some folds in the sweater. Sap Green, purple, and Burnt Sienna were used to describe the sand dunes. At this stage, much of the painting was painted wet into wet.

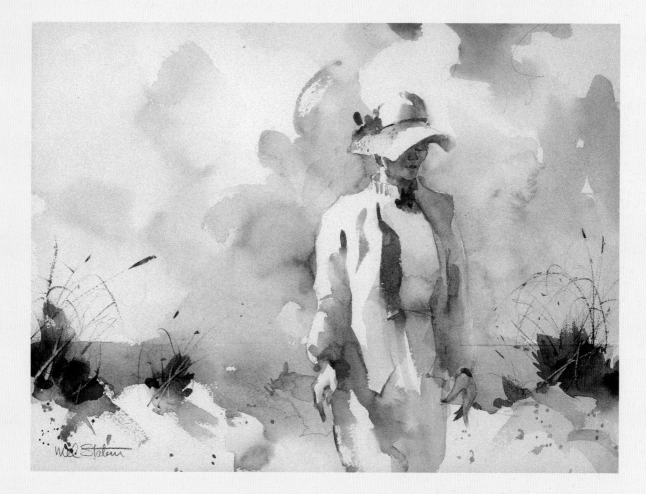

Morning on the Dunes, 15 x 11" (37.5 x 27.5 cm)

4. A touch of detail was added to the nose, lips, straw hat, and the cast shadows of the grass. Note how I connected the shadow of the sleeve facing the light with the cast shadow across the jacket and into the skirt. Unity in a painting is gained by having as few shapes as possible. To communicate the ethereal quality of early morning light, I kept the painting high key and the washes transparent.

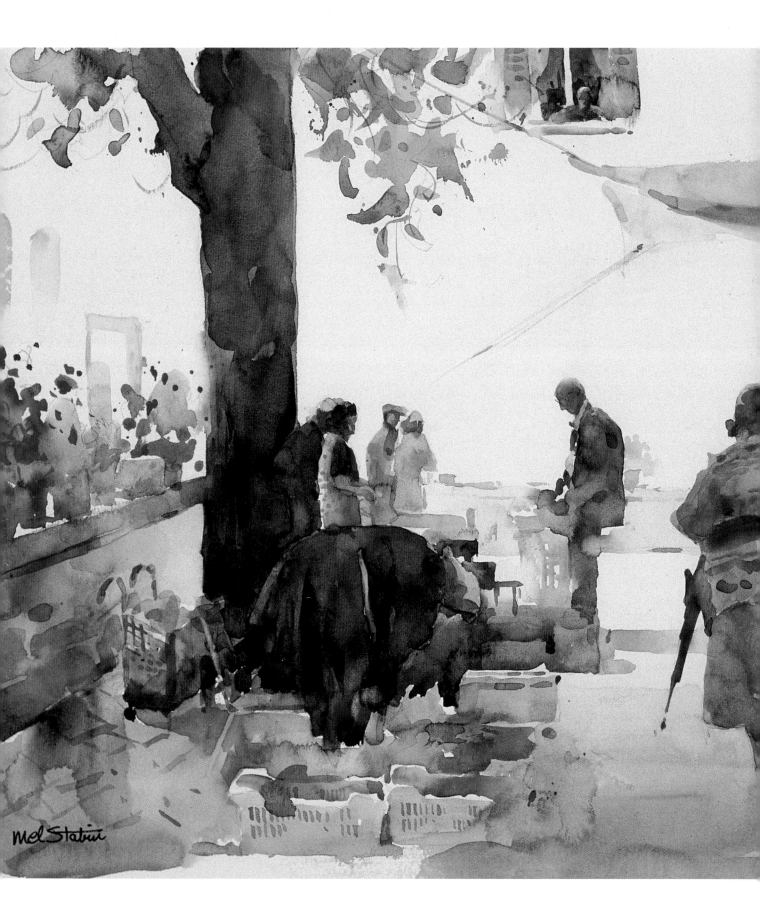

Groups of People

"To acquire knowledge, one must study; but to acquire wisdom, one must observe."

—MARILYN VOS SAVANT

Most of the watercolor workshops that I conduct here and abroad are done on location. Whenever I am near a marketplace, outdoor café, urban area, beach, park, or wherever people gather, I make sure that they are part of the painting itinerary.

I find painting groups of people in real situations to be irresistible and challenging. Of course, as with any challenge in life, it can also be frustrating, especially if you are not very experienced. To overcome these initial difficulties, do as Degas suggests that one "repeat the same subject over ten times, a hundred times until it is right."

Market Day in Assisi
15 x 22" (37.5 x 55 cm)

People in Their Environments

How do you paint busy people mulling around in some activity? Where do you start? I think the best way to start is to relax for five minutes or so and just empathize with the situation.

Choose a dominant figure or two that you can sketch quickly. You will always find a person in a group that is sitting or standing still long enough for you to draw. Then begin to build other figures around the dominant figure being mindful of designing them in relationship to the dominant figure and the environment.

Background elements should harmonize with the figures. Using echoes of colors throughout a painting helps to achieve harmony.

Take advantage of time in restaurants, cafés, pubs, subways, and airports, wherever people are waiting. It is a great opportunity to sketch or paint these people, who tend to stay put long enough for you to get something down on paper.

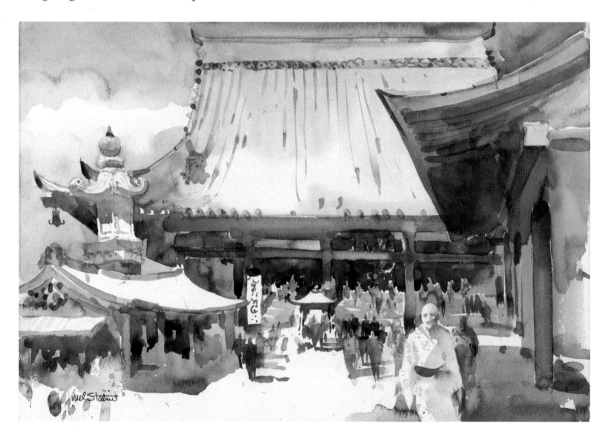

Senso-ji Temple, Asakusa, 15 x 22" (37.5 x 55 cm)

In a busy subject like this, controlling value and color relationships is very important. The dominant foreground figure of the priest was painted first in a very simple manner. I blended the shadow of the face into the shadow of the robe and indicated the design on the robe in the light area. I then silhouetted the light shapes of the figure with darker background shapes. Light midtone values described the overall shape of the crowd of people against the darker interior of the temple. I didn't get stuck in one place too long. I hopped around the painting, constantly developing relationships en route.

Street Market in Venice
16 x 24" (40 x 60 cm)

This painting has three values: light, midtone, and dark. I was interested in the abstract pattern of values and color in the buildings and marketplace. The figures had to be integrated into the rest of the painting so as not to stand out like a sore thumb. To accomplish this, I blended the shapes of the people into adjoining shapes. The slightly larger figure in the foreground dominates because of his size, warm skin tone, and the strong sunlight on his back. His shadow dissolves into the cast shadow on the ground. Many forms are treated as abstract shapes, especially in the dark shadow area under the canopies. There are six figures in this painting. Can you see them?

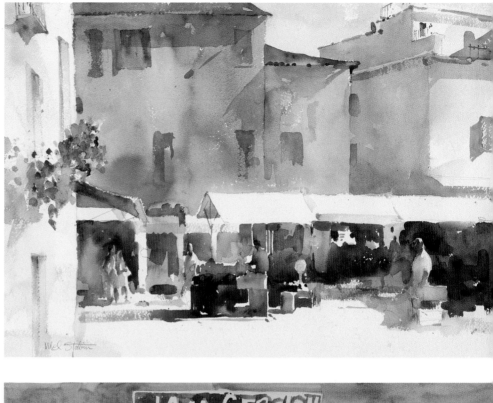

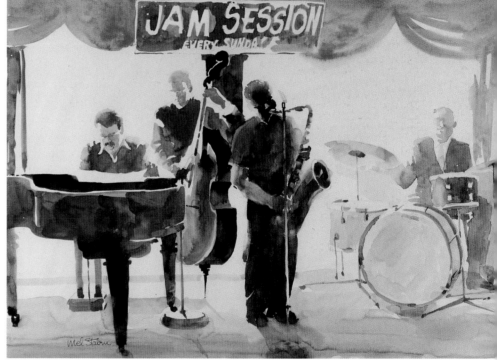

Jamming
15 x 22" (37.5 x 55 cm)

I excluded any activity outside the windows so that the focus was on the figures. The backlighting dictated strong value contrasts and color was a secondary statement. There is a dominance of blue and purple, made by using Prussian Blue and Alizarin Crimson. I chose this to reflect the low-key "jazz spirit," which was the essence of this subject.

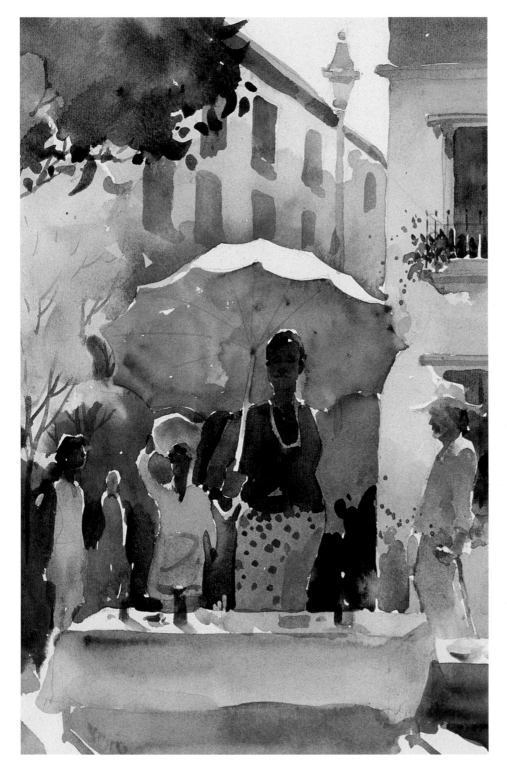

Oaxaca, Mexico
15 x 11" (37.5 x 27.5 cm)

I was attracted to the large, bright pink umbrella. First, I painted
the woman and then related the other figures to her. Some intense
Cadmium Yellow, Cobalt Violet, Sap Green, and Cerulean Blue were
used to reflect the rich colors of Mexico. The shapes of the people
were emphasized rather than detail of garments, facial features, etc.

Les Deux Maggots
15 x 22" (37.5 x 55 cm)

For reference, I used a small painting (7" x 10") I had done earlier of this restaurant in Paris patronized by many of the master Impressionist painters of the nineteenth century. Again, I selected a few figures and made them dominant in size, color, and value. Avoid making the dominant figures too melodramatic. You don't want them to overpower the rest of the painting. All elements of the painting should harmo-

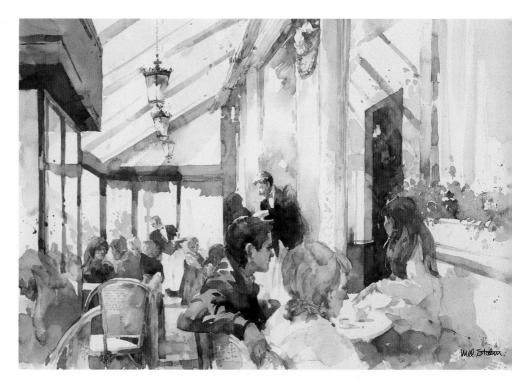

Assisi, Italy, 15 x 22" (37.5 x 55 cm)

The horizontal rhythm of people is subordinate to the dominant shape of the fountain in this painting. I made sure that the group of figures "read" well against the pinkish building. Since the figures are small their silhouettes become important. The forms of the figures are indicated with "blobs" of wet paint that were encouraged to mingle with each other. Some of the shapes are blended together some are not. A few of the figures are isolated. This "skipping" staccato rhythm adds to the excitement of the piece.

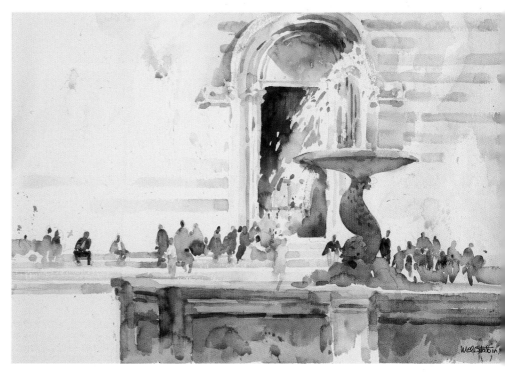

Piazza San Marco

1. Working across the paper from left to right, I applied a few light washes to the two foreground figures. The scene is backlit. I very quickly established the light value on the hat and arm of the second figure. Considering all of the activity of the subject, I was obliged to simplify and not get bogged down with detail. Anxious to establish a value pattern, I allocated a dark wash to the lamppost thereby creating three basic values: light, midtone, and dark.

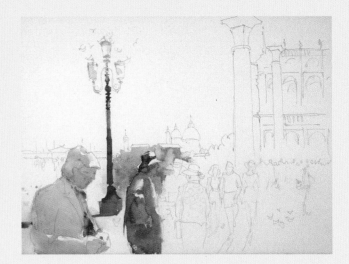

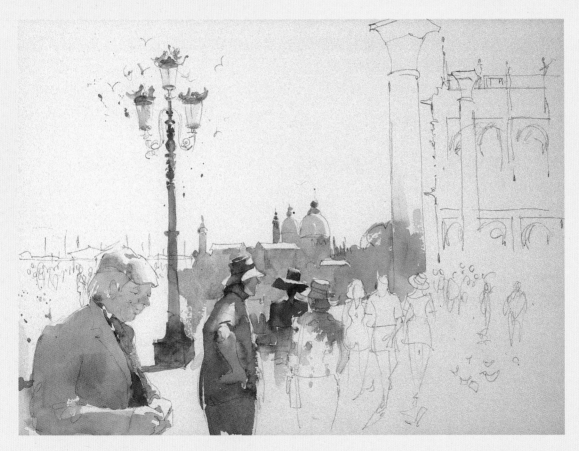

2. I continued my journey across the paper, extending the light midtone background that cuts around the figures. Silhouette shapes of a couple and more figures in the foreground were formed. The backlit figure of the woman in the wide-brim hat was painted wet-in-wet. My focus was on the relationship of color and value.

3. The oblique direction of the composition became apparent as the pillar was established. A few more figures were described with simple wet-in-wet washes and few brushstrokes. Cast shadows were added. I then indicated some folds in the jacket of the gentleman in the left corner of the painting.

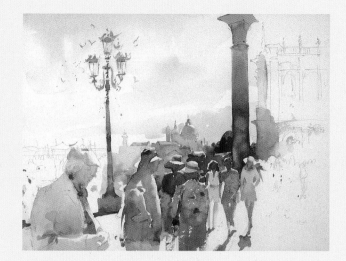

4. The Doge's Palace in the background was completed. A mere suggestion of windows and balconies in the palace was enough to give the architecture authority without getting fussy. With brisk brushwork, groups of small figures were then indicated below the palace. The features of the large figure on the left were defined as were his clothes. Pigeons were added as well as the shape of the gondolier station, and silhouettes of the pilings, and people above the large, foreground figure. Finally, a whisper for the sky was put in and the painting was completed.

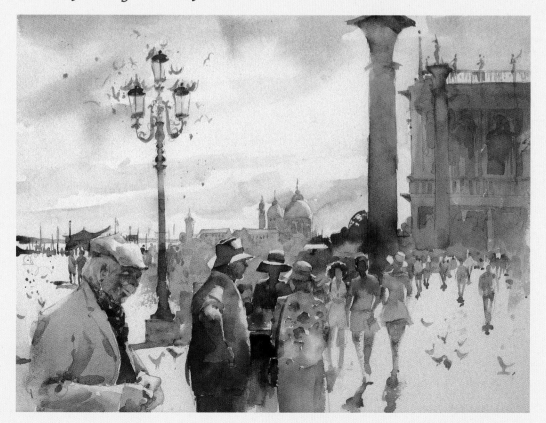

Piazza San Marco
11 x 15" (27.5 x 37.5 cm)

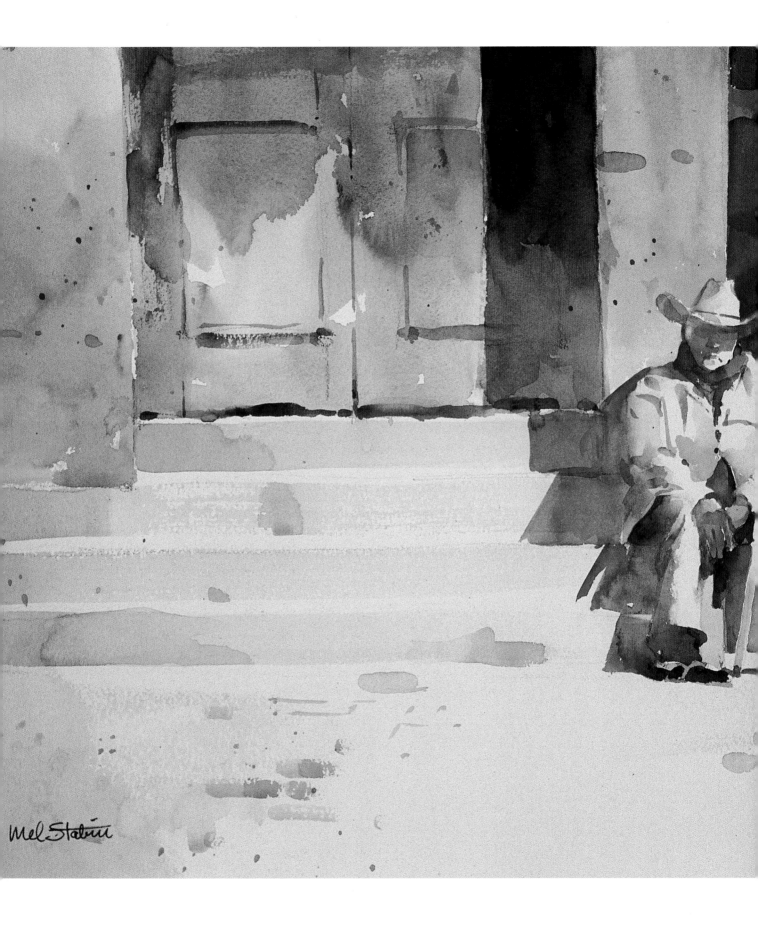

Painting from Photographs

*"Photographs record facts.
Artists delve beyond the facts."*

When you cannot paint people from life, you have three viable options: sketches, photographs, and memory. Although my preference is to use my sketches and memory for source material, I do work from photographs, which can be very useful when you want to capture the details of a fleeting moment.

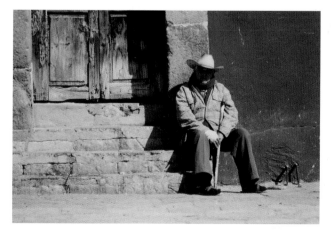

Photo for *Siesta in San Miguel*
Siesta in San Miguel, 15" x 22" (37.5 x 55 cm)

Making Choices

If you are using photographs for reference, here are a few things you should know. Take well-lit photos unless, of course, the subject is fog, rain, or nighttime. Black-and-white photos are especially useful because they make it easier to see values.

Do not try to painstakingly reproduce the photo. If you do, what is the gain? The painting will only reflect the skill of your hand and accuracy of your vision. What about your heart and mind? Photos lie. In a photo of a doorway, what may show up as black is probably not black in reality. Furthermore, photos do not always concern themselves with aesthetic order, harmony, balance, and so forth. We have to add this. That is why we make choices in painting.

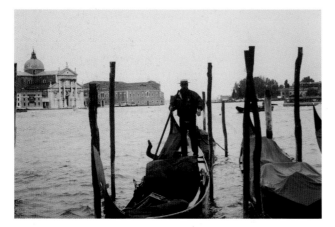

Photo for *Gondolier*

This photo suggests the mood of a gray day. The light is flat and backlit. I decided to raise the key of the painting a little and reduce the strength of the background buildings. The figure is still kept as a strong silhouette as are the gondolas and pilings even though they appear lighter than the reference. The values of the gondolas and pilings have more life to them in color and texture and because they are lighter than seen in the photo, they do not compete as much with the figure.

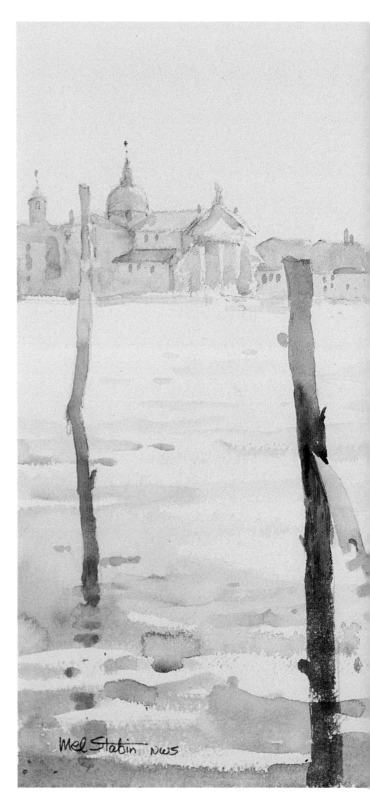

Gondolier, 15 x 22" (37.5 x 55 cm)

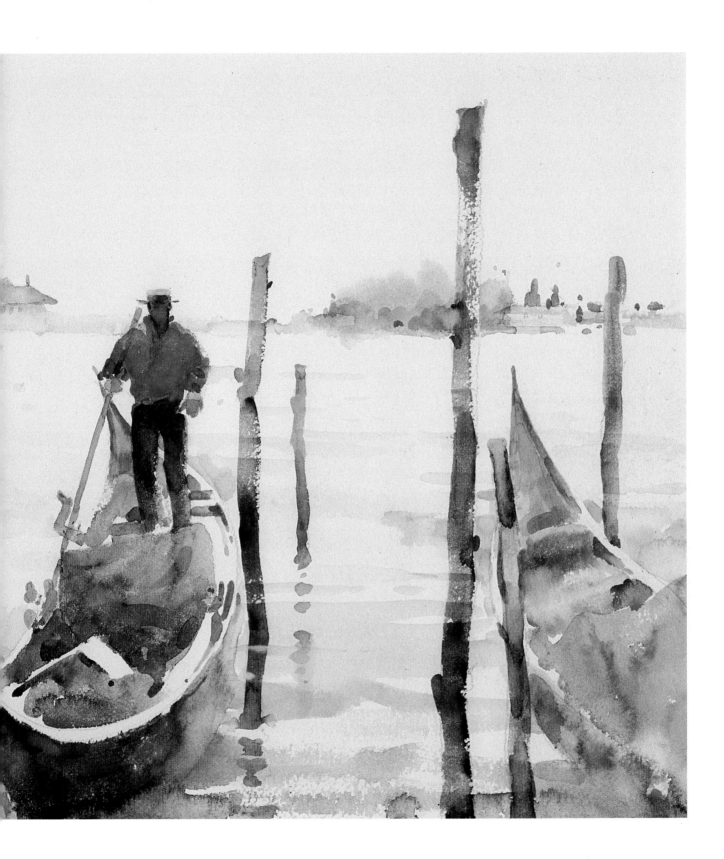

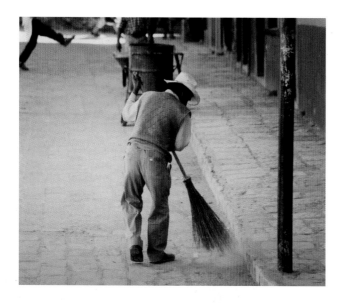

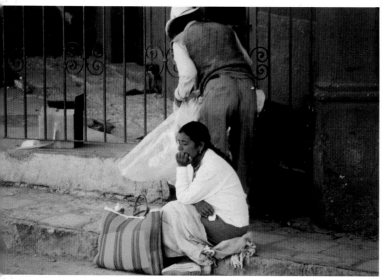

Photos for *Morning in San Miguel*

Morning in San Miguel, 15 x 22" (37.5 x 55 cm)
I often combine elements from different photos. I liked the gesture of the man sweeping so I positioned him behind the woman. I created a sense of morning light coming from the left. The strong diagonal line of the courtyard and the yellow shopping bag help rivet attention to the figures.

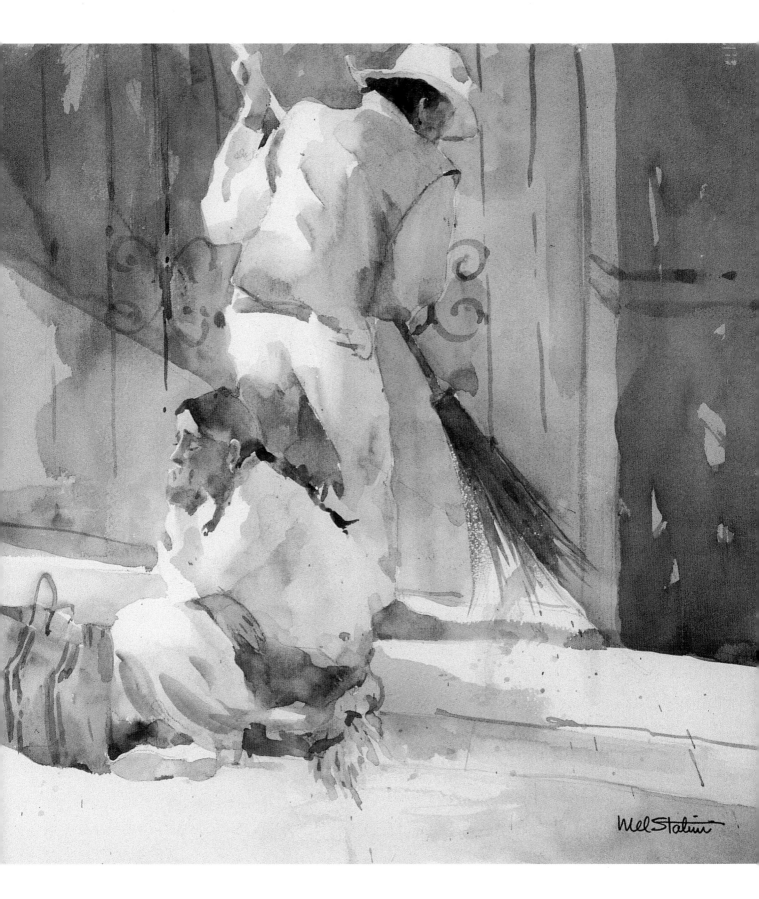

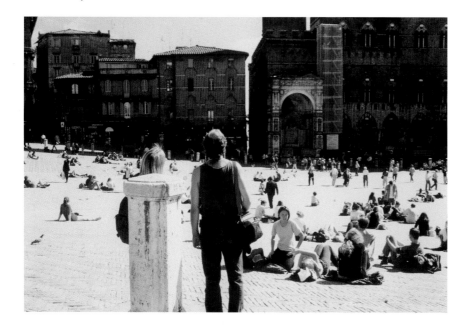

Photos for *Sunny Siena*

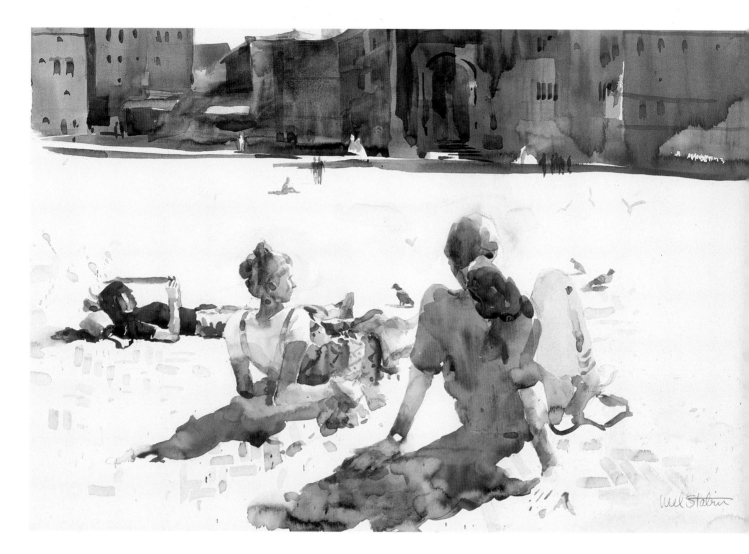

Sunny Siena, 15 x 22" (37.5 x 55 cm)

In the huge campo in Siena, Italy, sunbathing is a favorite pastime. I created a composition of the three figures receding in perspective and made the buildings a smaller shape in the background. The figures were painted first with rich, vigorous color changes, especially in the cast shadows.

The painter must interpret photographic reference, not paint it literally. For example, if I tried to include all of the brickwork as shown in these photos, the ground would have appeared too dark and I would have lost the sunlit quality I wanted to capture. If the cast shadow in the photo had been painted literally, it would have appeared dull and uninteresting.

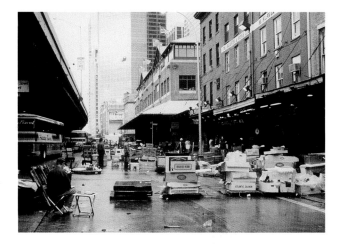

Photo for *Fulton Fish Market II*

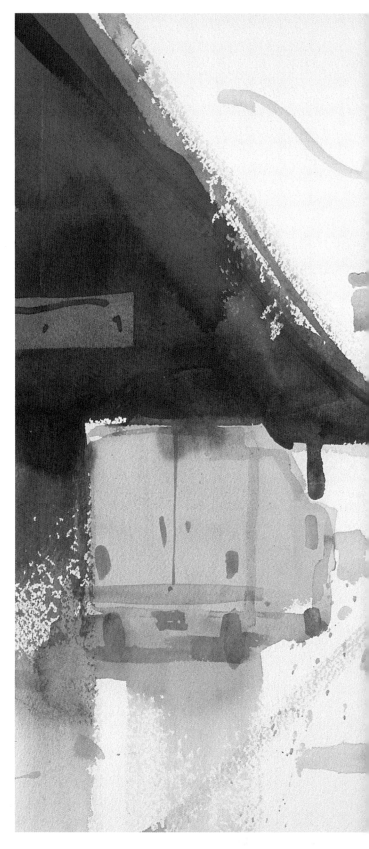

Fulton Fish Market II, 15 x 22" (37.5 x 55 cm)

The Fulton Fish Market in New York City is a busy place with guys crating boxes of fish, hosing down the street, loading trucks from 2 to 10 a.m. On numerous occasions, I sketched and painted this area, so I've become familiar with the scene. (You can see me in the left corner of the photo sketching away.) I established my value pattern of the buildings with my first washes and imposed some color excitement to reflect the chaos of the area.

The figures against the dark background were simple shapes of color handled abstractly. The foreground figure is an invention. Painting directly with the brush is the most spontaneous way to work and a great confidence builder. Note the variety of brush strokes, calligraphy, and combination of hard and blended shapes.

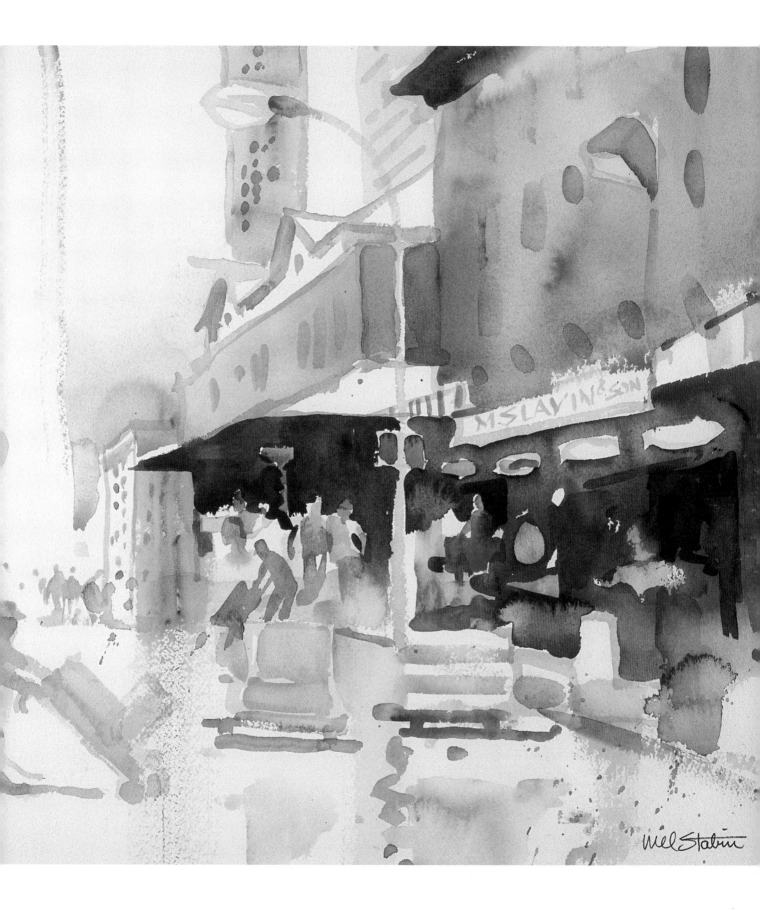

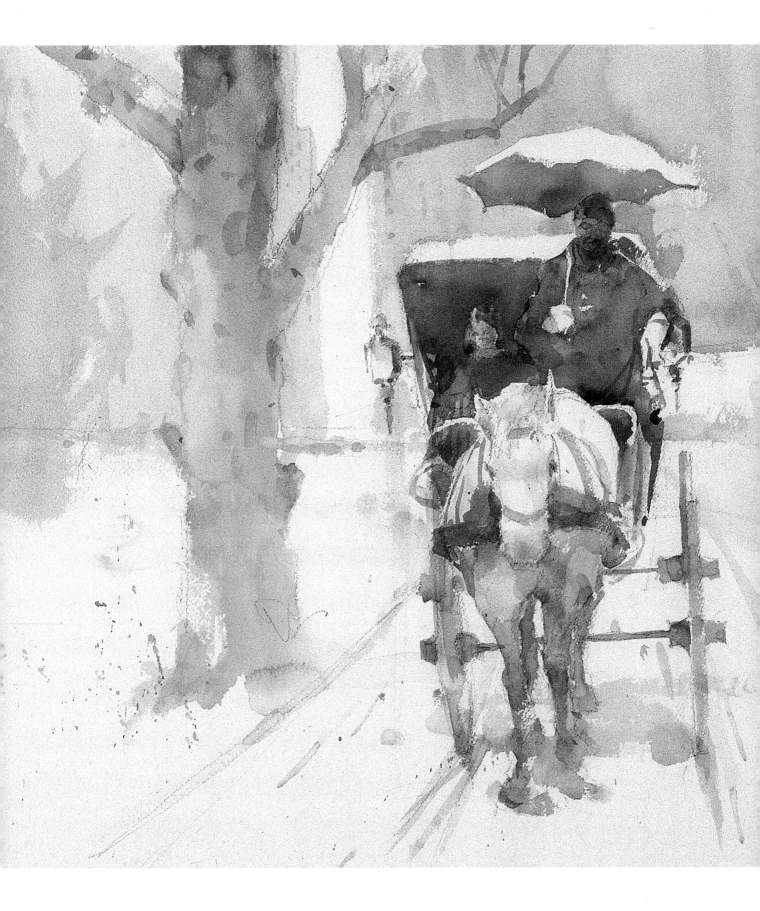

Mel Stabin

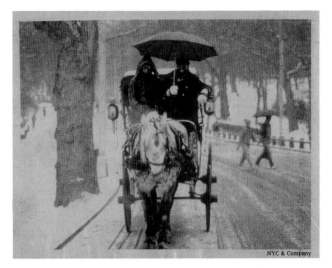

NYC & Company

Photo for *Central Park*

Central Park, 15 x 22" (37.5 x 55 cm)
Collection of Dr. and Mrs. Marc Levin

Working from old black-and-white photos frees a painter up to impose his own interpretation of color and mood on the painting. Notice the differences here.

I painted the figures and interior of the carriage together in a midtone value, wet-in-wet, so they would fuse together. The underside of the umbrella is the same value as the figures and carriage interior. The background of trees was treated as a flat, light midtone shape. Half of the painting was left as untouched white paper to suggest snow.

A Day At The Met II

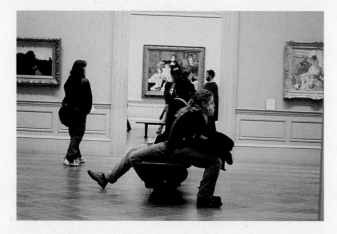

Photo for *A Day At The Met II*

1. I had Mondrian in mind when I composed the elements in this painting. Distinguished space divisions and variety in the dimensions of the rectangles were my first concern. Unlike the photo, the figures and the white wall were placed off center. Washes of Cerulean Blue, Yellow Ochre, and Raw Sienna were flooded onto the saturated wet paper and encouraged to mingle. I used my 2" flat squirrel-hair brush for these large initial washes.

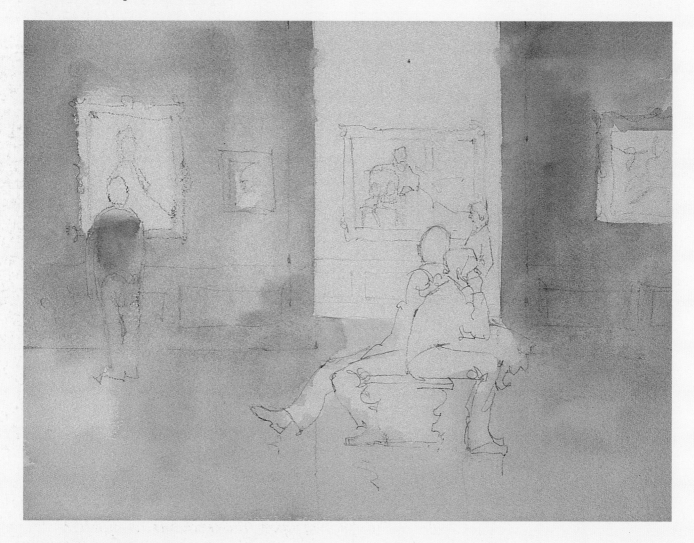

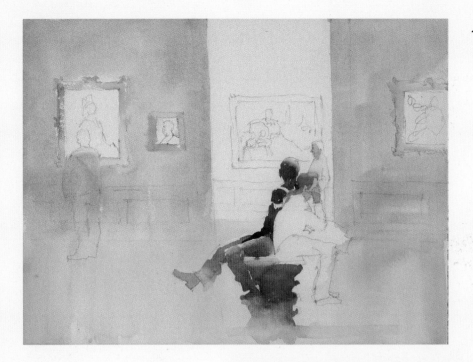

2. Quick brushstrokes of Yellow Ochre and Quinacridone Gold were applied to the frames. The foreground male figure was described with wet washes of Ivory Black, Cobalt Blue, Sap Green, and Burnt Sienna.

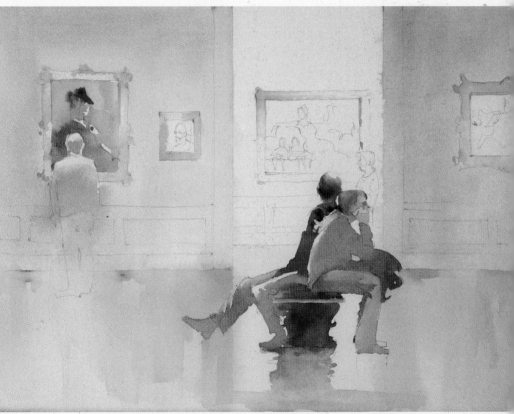

3. Darker reflections on the floor were indicated next. I then applied first washes for the foreground female figure and suggested the standing figure. The bench and its reflection were then indicated as one continuing wash.

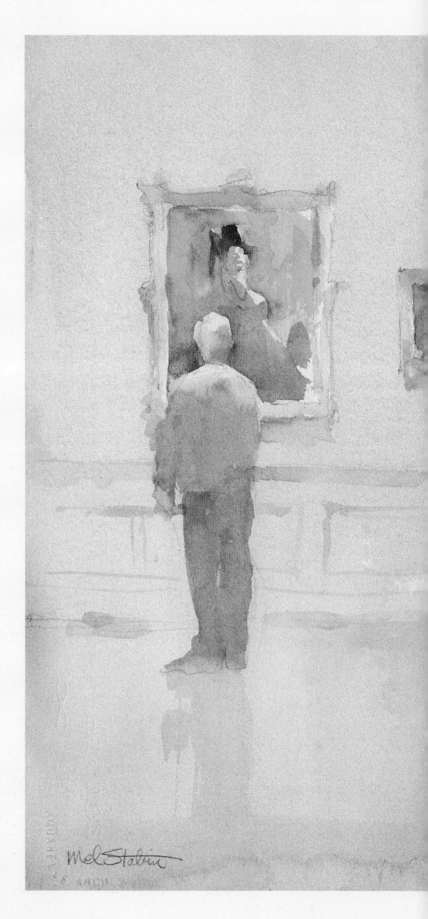

4. Second washes were glazed on the figures and quick brushstrokes were used to suggest folds in their garments. Images in the paintings and final touches on the frames were then completed.

The essence of these wonderful huge rooms at the Metropolitan Museum of Art (which I haunt) is the silence they inspire and the tranquility they evoke. That's what I was after.

A Day At The Met II, 15 x 22" (37.5 x 55 cm)
Collection of Ralph and Madeline Soukis

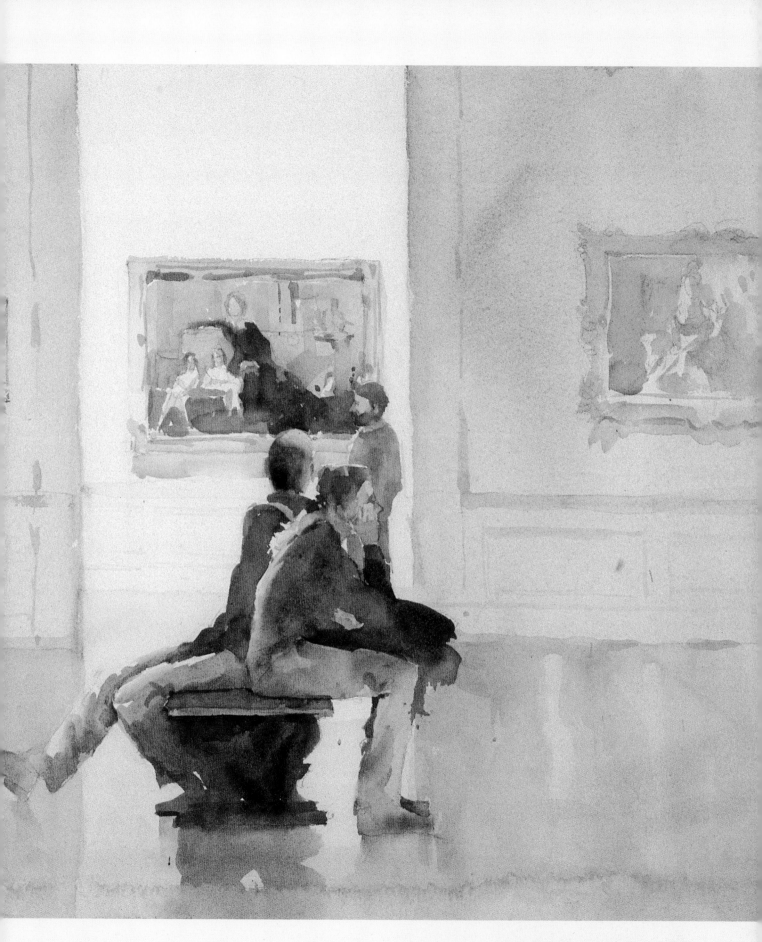

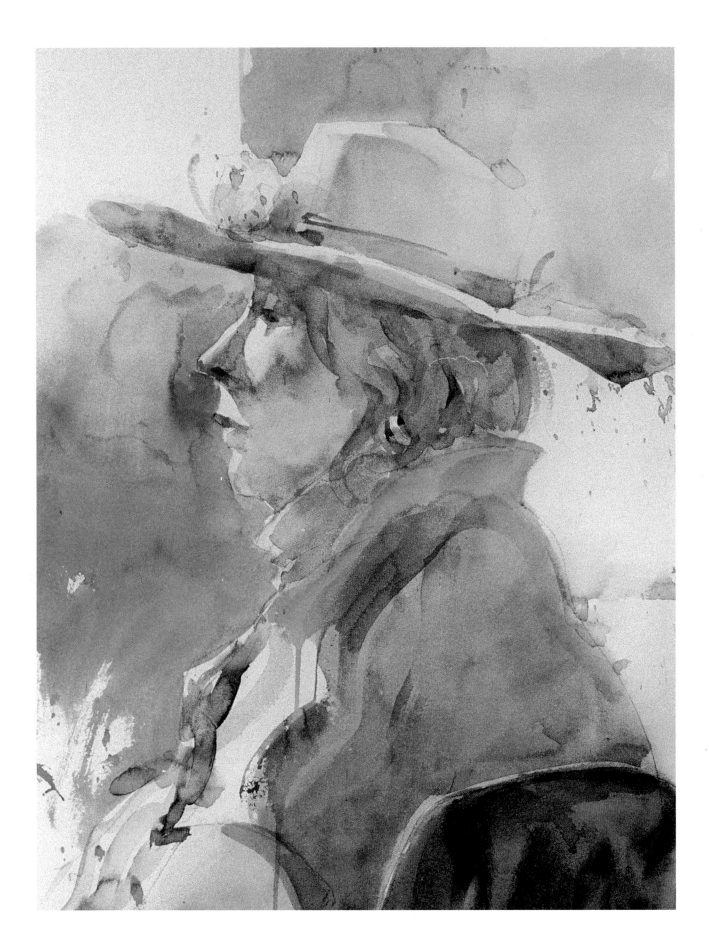

In Conclusion

"Some succeed because they are destined to, but most succeed because they are determined to."

—ANONYMOUS

No painting is a failure. A painting may be less than you would like it to be, but it has value nevertheless.

Be tolerant of failures. They teach and motivate more than success. Failures tell you that you can be better. Listen to them. Success can lull you into a false sense of security. It is great for our egos, but I caution you to be aware of its other insidious quality...complacency. When this occurs, growth ends and potentials may never be realized. Too many artists are seduced by the exterior appearance of success...fame, money, and outward adoration.

In truth, it is the very act of painting, the moment of creating that provides our greatest happiness, adventure and true reward. If your work is honest and sincere, you will know its worth. That is what matters. Have faith in yourself. You are your best teacher. Learn all that you can...and then some. Work hard. We, as artists, are tapped into a universal spirit that is not available to everyone.

Aren't we lucky?

Enjoy the ride.

Southern Belle, 22 x 15" (55 x 37.5 cm)
Collection of JoAnn Dolle

Index